WALES

A WALK THROUGH TIME

BRECON TO HARLECH

BRIAN E. DAVIES

AMBERLEY

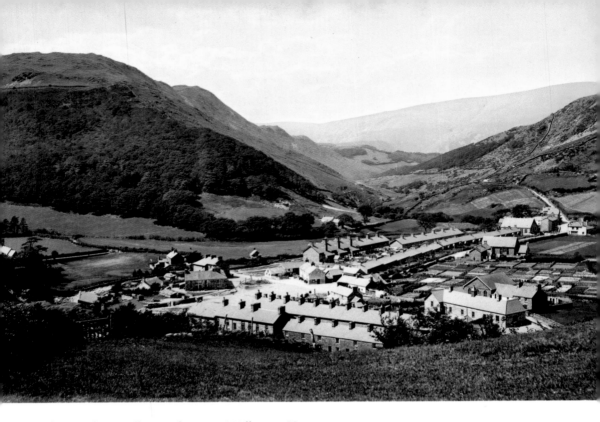

Abergynolwyn Village and Dysynni Valley, *c.* 1880

To my daughter, Lucy and son, Phil.

First published 2012

Amberley Publishing
The Hill, Stroud
Gloucestershire, GL5 4EP

www.amberley-books.com

Copyright © Brian E. Davies, 2012

The right of Brian E. Davies to be identified as the
Author of this work has been asserted in accordance
with the Copyrights, Designs and Patents Act 1988.

ISBN 978 1 84868 708 0

British Library Cataloguing in Publication Data.
A catalogue record for this book is available from
the British Library.

Typeset in 9.5pt on 12pt Celeste.
Typesetting by Amberley Publishing.
Printed in the UK.

Contents

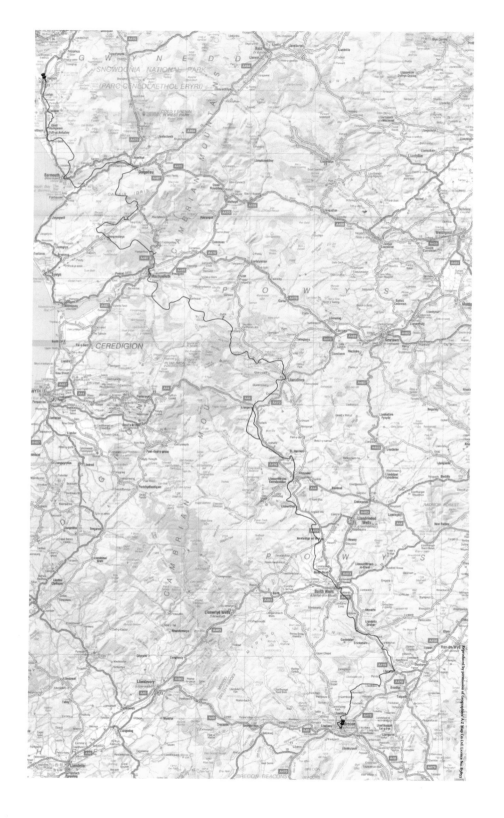

Acknowledgements

I would like to thank Pat Ward for his photographic assistance and those who kindly contributed images and information, including: National Museums of Wales, National Library of Wales, Powys County Archives, Powysland Museum, Llanidloes Museum, Cambridge University Library, Cadw (The Welsh Government's Historical Environment Service), Brecknock Museum & Art Gallery, Countryside Council for Wales, Gwynedd Council, Snowdonia National Park Authority, Museum of Modern Art (MOMA WALES), Forestry Commission, Ginny Cooke and Helen Tatchell from Powys County Council, David Bellamy, Pat Power and Builth Wells & District Heritage Society, Lloyd Lewis, Gigrin Farm, Radnorshire Wildlife Trust, Clochfaen Hall, Plas Machynlleth, Owain Glyndwr Centre, Richard Williams, Corris Railway, Centre for Alternative Technology, Dave Williams, Talyllyn Railway, Mary Jones Walk, Phill Stasiw, Ras y Gader, Dolgellau Heritage Society, Clive Evans, Ywain Myfyr, Gruff Ywain, Keith Davies, Hugh Roberts, Stan Taylor.

Publications referred to include: *Gerald of Wales* (trans. Lewis Thorpe), *Encyclopaedia of Wales*, *Wye Valley Walk* (Official Route Guide), *Photographs of Old Builth Wells*, *Portrait of Wildlife on a Hill Farm* (Anne McBride, Tony Pearce & Darren Rees), *Chartist Outbreak at Llanidloes* (Powys County Council), *Glyndŵr's Way National Trail Guide* (David Perrott), *A History of the Dylife Mines and Surrounding Area* (Michael Brown), *A Pictorial History of Machynlleth* (David Wyn Davies), *Wild Wales* (George Borrow), *In Search of Wales* (H. V. Morton), *Harlech Castle* (Arnold Taylor) and local trail leaflets and guides including those for Builth Wells, Rhayader, Llanidloes, Dolgellau, Machynlleth and Barmouth.

The internet has been invaluable, particularly the Powys Archives Digital History Project, Clwyd-Powys Archaeological Trust (CPAT) and local town and tourism websites.

Ordnance Survey Maps reproduced: © Crown Copyright. All rights reserved. Licence number 100050463.

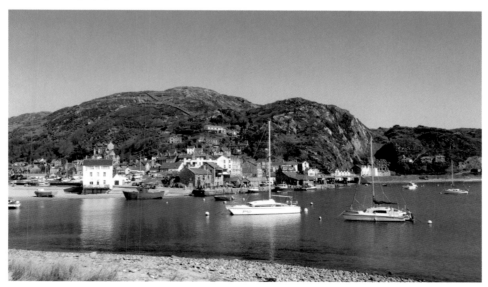

Barmouth from Ynys y Brawd

Introduction

On 11 December 1282, when Prince Llywelyn ap Gruffydd was killed at Cilmery, near Builth Wells, the dream of Welsh nationhood perhaps suffered its most severe blow. Llywelyn had travelled to Builth seeking alliances with the local chieftains after defeating the English in the north at Menai Strait, but became separated from his army and was ambushed. Following the defeat of Llywelyn, the English King Edward I built his great ring of castles to subdue the Welsh, including the stronghold of Harlech, where our journey will end.

A century earlier, Giraldus Cambrensis, then Archdeacon of Brecon, had journeyed through Wales recruiting for the Third Crusade. He wrote in his *Description of Wales*, 'if their princes could unite to defend their country or if they had only one prince and he a good one, I cannot see how so powerful a people could ever be completely conquered. If they were united, no one would ever beat them. The English are striving for power, the Welsh for freedom'. This unity and freedom were not realised however – although in 1404, Owain Glyndŵr was crowned Prince of Wales at his parliament in Machynlleth following his heroic but ill-fated rebellion. In 1485, Henry Tudor marched through Wales towards his triumph at Bosworth and a Welshman finally ascended the throne of Britain, beginning one of the greatest dynasties in British history.

We'll meet these historic figures on our journey when we visit some of the places associated with them, amidst the magnificent scenery of central Wales. We'll also explore many other interesting sites including long-lost woollen mills, lead mines and slate quarries.

Our 136-mile walk from Brecon to Harlech is the second part of a journey from the southernmost to the northernmost point in Wales, which started at Flat Holm Island and will ultimately finish in Anglesey. I've chosen the route and accompanying images to showcase the spectacular landscape and rich heritage of Wales and each chapter describes an attractive section of the journey. Some sections may be walked in a day while the longer sections can be divided over two days if so wished. The walk starts at the historic market town of Brecon and links up with the Wye Valley Walk at Llyswen. It follows this splendid river and hill trail, visiting the towns of Builth Wells and Rhayader, before following a bridleway to Llanidloes. The route then follows Glyndŵr's Way National Trail through the Cambrian hills to Machynlleth before visiting the fascinating Centre for Alternative Technology. We visit the beautiful Tal-y-llyn Lake and climb over the iconic peak of Cadair Idris to reach the town of Dolgellau, followed by a gentler stroll along the scenic Mawddach Estuary to the seaside at Barmouth. Finally we follow part of the Ardudwy Way upland trail to arrive at Harlech with its great castle.

The 1/50,000 scale Ordnance Survey maps and route descriptions included in the text should enable the walker to follow the route without difficulty. More detailed 'Explorer' 1/25,000 OS maps are a useful additional aid and the Official Trail Guides for the Wye Valley Walk and Glyndŵr's Way are also recommended. The route crosses over some high and exposed ground and weather conditions can change very quickly so it's important that proper clothing and equipment are used. Adequate supplies of food and drink should be carried and a map, compass and whistle are always essential items.

I've again featured some of the interesting and welcoming hostelries along the route and these are well-placed to provide rest and refreshment for the weary walker!

Brian E. Davies
1 June 2012

Chapter One

Brecon to Llyswen

11.9 miles (19.2 km)

From the Honddu to the Wye

We start our long journey to Harlech from the timeless market town of Brecon and the first leg is a pleasant 12 mile walk through quiet country lanes and over Llandefalle Common to meet the Wye Valley Walk at Llyswen. We'll visit Brecon Cathedral and then walk along the attractive valley of the Honddu to the little village of Llanddew, where the celebrated Norman–Welsh cleric, Giraldus Cambrensis, who completed his own journey through Wales in the twelfth century, once lived. We'll enjoy some great views of the Brecon Beacons and Black Mountains and explore the old church at Llandefalle before passing Brechfa Pool Wildlife Reserve to arrive at the village of Llyswen.

We start at The Bulwark, in the centre of Brecon, illustrated (below) in a *c.* 1850 engraving, with the Shire Hall to the left and St Mary's Church ahead. The classical Shire Hall, built in 1842, was once the Courthouse and now houses the Brecknock Museum & Art Gallery. As we approach the church, the iconic statue of the Duke of Wellington is in front of us and as we pass to the right of the church along High Street, the Guildhall is on our right, which dates from *c.* 1770 and replaced an earlier council house on the same site. The ground floor was once an open arcaded market but is now enclosed and houses the Town Council chamber.

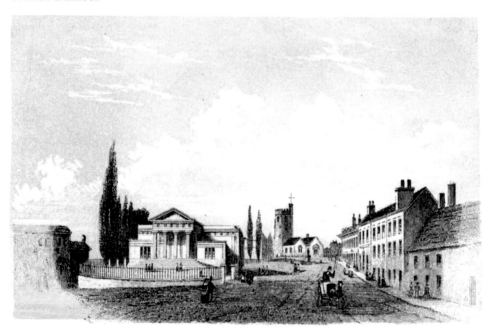

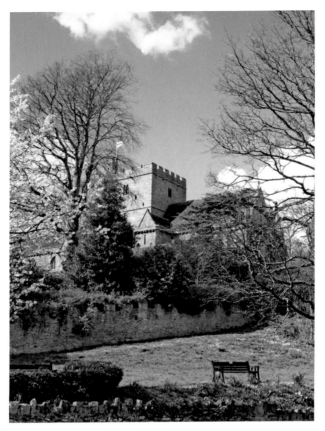

We bear around right on the High Street then along The Struet, continuing over the crossroads. When we reach the Bull's Head, we turn left over the Honddu Bridge and if we look up through the trees we can see Brecon Cathedral (left). To reach it we walk up Priory Hill before crossing the road to enter the gate into the Cathedral Close.

The cathedral's site dates back to Celtic times and in 1093 the Norman knight, Bernard de Neufmarché, founded a Benedictine Priory here. When the monasteries were dissolved, the Priory continued as the Parish Church of St John the Evangelist, achieving cathedral status in 1923. The cathedral has many fascinating features including an ancient font and magnificent stained glass windows. The cathedral also contains the Havard regimental memorial chapel where the Colours on display include the Queen's Colour gallantly saved following the battle at Isandlwana in the Zulu War of 1879. The heroic defence of Rorke's Drift followed in the aftermath of the disastrous battle.

There's a heritage centre and tearoom in Cathedral Close, which we leave by the top gate to turn right through the lych gate. We pass through the churchyard and through a gate, and then turn left to start our pleasant walk along the left side of the Honddu valley. We fork right where the tarmac path bends left and follow the signs to Anod Bridge, ignoring paths leaving the route to the left. The river is down to the right, and at an unmarked fork there's a choice between upper and lower paths. The upper path is more straightforward while the lower path includes a pleasant stretch by the river.

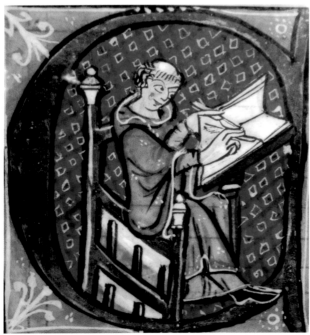

We eventually cross a stile and bear right down the field to the river bank, following it to Anod Bridge. We cross over the bridge to fork right up the steep lane to Llanddew Village. Llanddew was an early medieval clas religious foundation and its peaceful St David's church dates from the thirteenth century. Giraldus Cambrensis (Gerald of Wales, *c.* 1145–1223) lived in Llanddew after becoming Archdeacon of Brecon in 1175. He held the post for many years, having failed in his long-held dream of becoming Bishop of St David's. Gerald greatly loved his 'tiny' house here, which was 'conducive to thoughts of the next world'. The archdeaconry was situated at or near to the fortified Bishop's Palace (Llanddew Castle), established here in the twelfth century. Both archdeaconry and palace became ruined by the mid-sixteenth century.

In 1188, Gerald accompanied Baldwin, Archbishop of Canterbury, on a tour through Wales, recruiting for the Crusade, and they preached and stayed in Llanddew during their odyssey. Gerald's book *The Journey Through Wales* is a travel diary of their preaching tour which lasted six weeks and took them to many parts of Wales. They persuaded around 3,000, mainly Welshmen, to 'take the Cross' and it's probable that many of these accompanied Richard the Lionheart on the Third Crusade to the Holy Land. Gerald himself set out for the Holy Land, together with Baldwin, crossing over to France in the spring of 1189, but when Henry II died at Chinon, Richard I sent Gerald back home to attend to

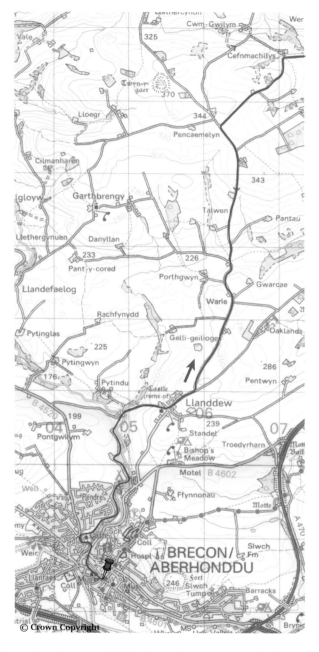

political matters and he was absolved from the Crusade. Baldwin kept his vow and made his way to Acre, where he died in the siege on 19 November 1190.

The thirteenth-century manuscript illumination (opposite) depicts Gerald writing one of his many books. 'Reproduced by kind permission of the Syndics of Cambridge University Library' Ff.127 Page 253.

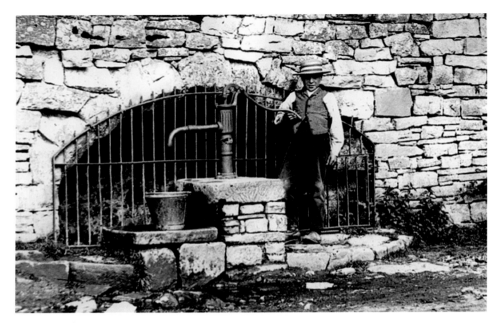

Llanddew's village pump is fed from a fourteenth-century double-sided well in the wall of the palace and has been restored since it was pictured *c.* 1900 (above). The public well face is opposite the churchyard, looking towards the lane – another well face inside the palace wall was used by the private palace residents!

It is uncertain which route Gerald followed, riding from Hay-on-Wye to Llanddew then on to Brecon, but our route turns left past the old Bishop's Palace gateway and its little garden (left), which is an attractive remnant of the long-disappeared palace. Other attractively-conserved remains of the palace-castle survive in the grounds of the vicarage that was erected on the site in 1857.

After about a quarter of a mile we bear left on the lane signposted to Llaneglwys. We follow this country lane for almost 2.5 miles, with increasingly impressive views of the Brecon Beacons behind us as we ascend (opposite, top).

The countryside opens out as we reach Warle then, after going downhill and up again, we pass the turning to Funglas and take the next turning right along a narrow lane towards Cefnmachllys and Wernddyfwg (not signposted). There are more great views here with the Black Mountains now appearing to our right. We drop down to cross a little bridge over the stream then pass through a couple of gates at Wernddyfwg farmyard and onto Llandefalle Common. When we meet the lane junction, we go straight across and head due east along a grassy track with the hedge to our right.

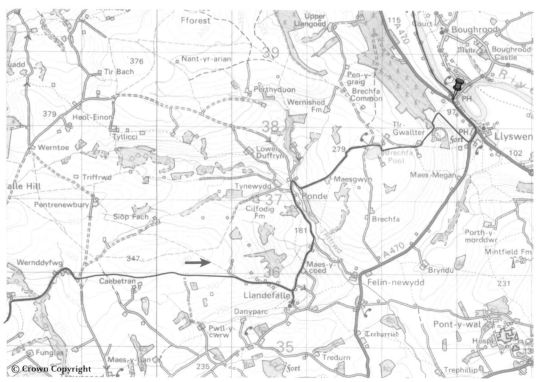

© Crown Copyright

Shortly, we veer away from the hedge to pass a fence corner and a gate to our right before continuing on a clear track eastwards over the common, enjoying the magnificent views.

A compass is useful here, so that an easterly direction can be maintained, paralleling the right-hand edge of the common. We pass Caebetran to our right and continue straight on, ignoring a track to the right where the hedge veers away towards Pwll-y-cwrw (Pool of Beer). Apparently when the stream near here becomes flooded, it forms brown pools which look like beer!

Our path meets the hedge again and continues to follow it eastward – the path is indistinct here and it crosses ground which may become boggy in wet weather, but we soon emerge onto the end of a lane. We bear right down this pleasant lane towards Llandefalle and at the bottom, where the lane turns left, we turn right down a steep track to make a short detour to view the white-painted Parish Church of St Matthew (left, top). Situated on an ancient elevated site, the present church dates back 700 years and was restored and enlarged in early Tudor times. The interior has an impressive high roof and there's an interesting stone tablet listing charitable benefactions given to the poor of the parish in the seventeenth and eighteenth centuries.

We retrace our steps steeply back up to the lane junction then, after about 30 yards, where the lane bends right, we go straight ahead down a track with grass in the middle. The track passes Maes-y-coed and a couple of cottages before we turn left on the lane to reach Ponde.

Following around the bend here, we then turn right opposite Ponde House along a track which soon curves left and becomes a sunken lane between two hedges. This leads to Maesgwyn farmyard, where we pass through a couple of gates, continuing on the lane towards Brechfa Pool. We pass Bethesda Chapel, built in 1803 by public subscription and now a private property.

The Brechfa Pool Wildlife Reserve (left, bottom) is noted for attracting migrating birds, and breeding birds here include mute swan, lapwing and black-headed gull.

We skirt around the pool to its south-east corner, continuing on a grassy bridleway which soon meets the lane. At the end of the lane we continue down the narrow bridleway, shortly turning left over a stile to join a footpath which offers some great views (the bridleway ahead leads steeply down to Llyswen but is very wet, muddy and hazardous). We angle across the field to a gate then follow the footpath signs across the next field to a stile, continuing on to drop down a steep bank to another stile at the bottom. There's a good view of the horseshoe bend in the Wye coming down here. The ongoing path through the wood is indistinct, initially bearing left before bending down right to a stile, visible in the bottom fence. Reaching it, there's a view of Boughrood Bridge as we head down the field to reach a stile in the bottom right corner, crossing it and then several more stiles with the village of Llyswen down to our left. We emerge near the main road, turning left to arrive at Llyswen with its welcoming Griffin Inn. The picture (below) shows the village scene c. 1955 – the cottages on the left now accommodate the well-named 'Wye Knot Stop Café'.

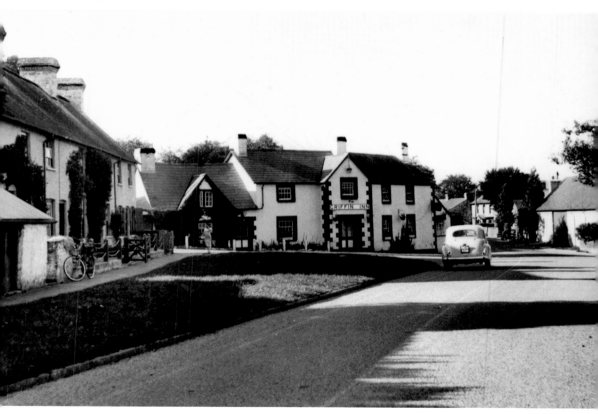

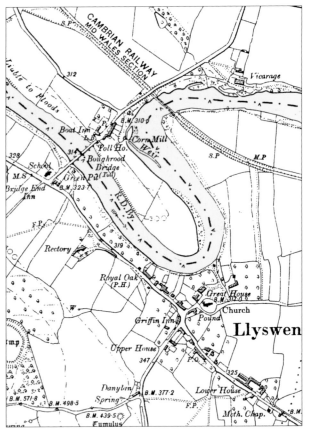

The Griffin Inn is said to date from 1647 and has received a 'trim' since the picture (above) was taken! The lane on the opposite side of the main road leads to the pretty St Gwendoline's Church, which was rebuilt in Victorian times, but retains an ancient quality.

Llyswen (White Court) is situated on a horseshoe bend of the River Wye and its partner village, Boughrood, is on the other side. The Annual Llyswen and Boughrood Show held every August on the Boughrood side is enlivened by tug-o'-war contests between rival teams from the two villages! The old 6-inch/mile map (left) shows the village in 1905 with Boughrood Toll Bridge linking the two villages and the old Mid Wales (Cambrian) Railway on the far side. A further half-mile walk alongside the A470 leads us to the Bridge End Inn at Boughrood Bridge and our finishing point for the day.

Chapter Two

Llyswen to Builth Wells

12.6 miles (20.3 km)

The Wye Valley Walk

Today we join the route of the Wye Valley Walk and during the next three chapters we'll cover some 41 miles of this long distance trail, a perfect mix of river and hill walking. The excellent Official Route Guide describes the entire 136-mile trail in great detail and the concise directions included here should enable the route to be followed without difficulty, particularly as the path is well waymarked with the 'leaping salmon' logo. We'll enjoy the wonderful river and surrounding countryside today as we follow the Wye as far as Erwood Old Station before continuing over the hills to the fine market town of Builth Wells.

We join the Wye Valley Walk just past the Bridge End Inn at Boughrood Bridge pictured (below) *c.* 1955. The bridge is at a historic crossing point of the river, which formed the boundary between the old counties of Radnorshire and Breconshire. On the Radnorshire side stands the village of Boughrood (Bach-rhyd or 'little ford') named after the ford that preceded the bridge and where once 'a boat and horse were in constant attendance'. The old Boat Inn, which stands near the crossing on the other side, has sadly recently closed. The toll bridge replaced the ferry in the 1830s and the old toll house still survives on the other side although tolls ended in 1934.

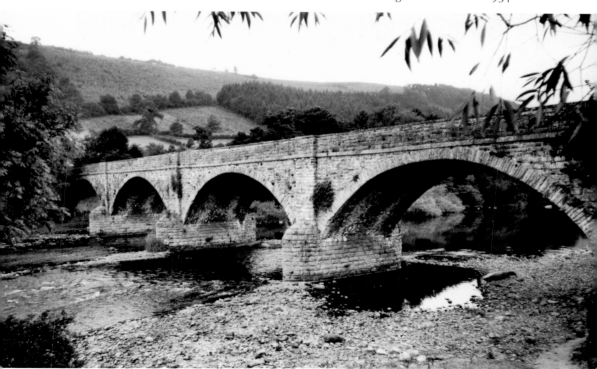

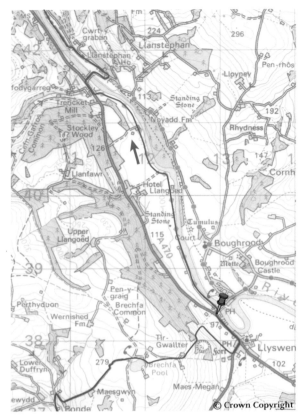

© Crown Copyright

Our route initially follows the riverside lane before continuing along the footpath on the west bank of the river. We soon pass a 'secret' graveyard behind an old stone wall where notables from Llangoed Estate are buried, including the notorious John Macnamara, who was said to have won the estate in a high stakes gambling game in the eighteenth century. Llangoed Hall is now a beautiful country house hotel, seen across the meadow to our left (below). Formerly known as Llangoed Castle, the site of the house apparently dates back as far as AD 560 and is said to be where the first Welsh parliament was held. It was rebuilt in 1632, in the classic Jacobean Manor House style, and was later restored and redesigned by the celebrated Welsh architect, Sir Clough Williams-Ellis. Until recently the hotel was owned by the late Sir Bernard Ashley (husband of interior designer Laura Ashley) who bought the hall in 1987 and restored it to its former glory.

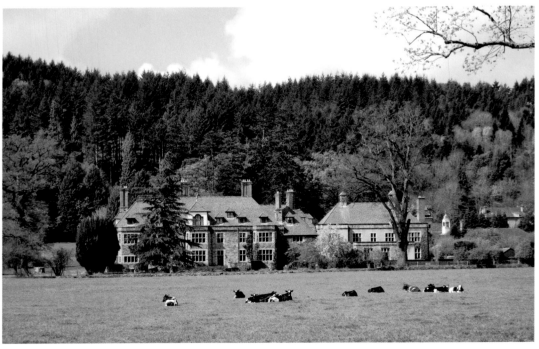

Just over a mile further on, the riverside path reaches the point where the Sgithwen Brook joins the Wye. We turn left to follow the brook to the main road, where we turn right on the grass verge before turning right again to cross the river over Llanstephan suspension bridge. This charming single-lane bridge (right) dates from 1922, and allows just one vehicle to cross at a time. After crossing the bridge, we continue around to cross the line of the old railway, before turning left at a T-junction. After about 600 yards we turn left through a gate to follow a track along the riverside. After crossing a little footbridge over the tumbling River Bachawy we pass under the old railway viaduct and then go left over a stile to the road, where we turn right. This section of road follows the old railway track bed for just over a mile to reach Erwood's old station.

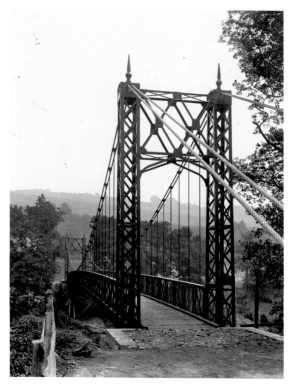

© Crown Copyright

Erwood Station's buildings have been tastefully converted into an attractive Craft Centre and Gallery that's well worth a visit. Erwood was one of the many rural stations along the old Mid Wales Railway line that opened in 1864, linking Llanidloes and Brecon. The line carried goods and livestock as well as passengers but, sadly, closed in December 1962 as part of the Beeching axe. The splendid painting by David Bellamy (below) captures the atmosphere of Erwood Station in its days of steam. The craft centre holds arts & crafts exhibitions in its restored railway carriages and includes a shop and café where excellent refreshments may be enjoyed. There are also regular demonstrations by local craftsmen including wood-turning and painting. A diesel locomotive restored by the Friends of Erwood Station may be viewed outside as well as a signal box, rescued from Newbridge-on-Wye and now used as a bird hide.

The Wye Valley Walk leaves the station picnic area by a gate in the corner, following a path to the road, where we turn right to cross the River Wye Bridge. There was a toll bridge here at one time and another Boat Inn near to the river, which suggests an earlier ferry crossing. There's a great view of the river from the bridge, looking upstream (opposite, top). We reach the A470 road and cross over carefully to take the minor road opposite, climbing steeply up to Twmpath Common. Looking back across the valley, there's a German howitzer gun visible atop the grassy hill of Twyn y Garth, erected there to mark the end of the First World War and in memory of the locals who lost their lives.

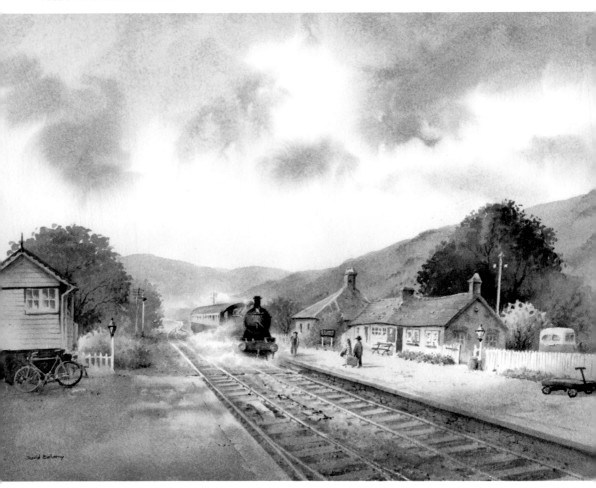

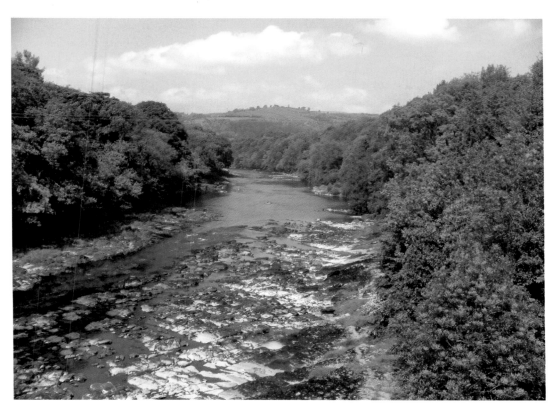

After about 0.7 mile, we leave the road by forking right at a finger post opposite a 'Twmpath' sign and head north-west on a path across the open common. There are fine views here, giving perspective to the river and the valley. At the bottom of the slope we leave the common at a gate and fingerpost, beyond which there's an old track way. Following the waymarked path ahead we reach a footbridge crossing the Fernant stream, leading up to a minor road. We turn left here and follow the road uphill and onto Little Hill Common where there's another great view of the valley (right). We continue on the road along the edge of the common for nearly a mile with a view of Aberedw Rocks across the valley, over to the right. Among these rocks is Llywelyn's Cave where the last native Prince of Wales is said to have hidden from his enemies before being pursued and killed at Cilmery, near Builth Wells.

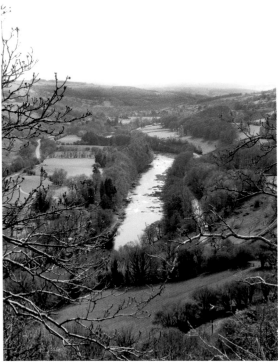

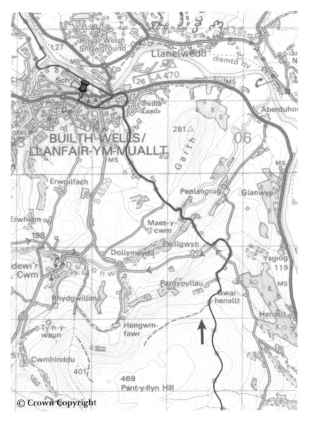

© Crown Copyright

We take a left off the lane at the Old Bedw turning, continuing ahead up the bridleway leading to the common (ignoring the access to Old Bedw itself). We follow the fence line uphill for 500 yards then turn right on the bridleway across the common. Continuing over the open hill, we cross two small streams and pass through two fields, keeping to the hedge and fence lines. Eventually, after a gate, we turn right and head downhill to another gate where we leave the open hill. We now follow a track through gates to a lane where we turn right to reach a crossroads at Bedw-fach. Here we go straight across to follow a delightful little loop, swinging left to another crossroads where we turn right down a sunken lane past Dolfach Cottage to a footbridge over the River Duhonw. From here we follow the lanes ahead down into Builth Wells.

Reaching Castle Road, we turn right to head into town, passing the castle mound on the left. It's worth exploring the great mound, which has extensive earthworks and splendid views from the top. Little remains of the once formidable castle and the site now forms a peaceful haven in the centre of town. The early Norman wooden motte-and-bailey castle was probably built around 1093 and it was later taken and destroyed by the Welsh Princes, including Llywelyn Fawr (Llywelyn the Great). During the wars against his grandson, Llywelyn ap Gruffydd, it was won back for the English King Edward I, who built a new stone castle between 1277 and 1282. The final days of Llywelyn ap Gruffydd are depicted in a mural, seen approaching the town centre (left).

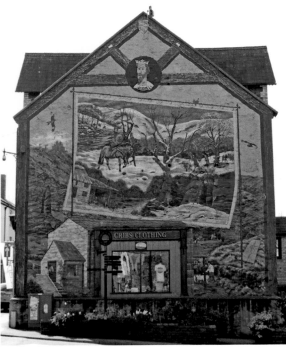

Prince Llywelyn's death on 11 December 1282 is still remembered as a severe blow to Welsh nationhood. After defeating the English army in the north, Llywelyn came to Builth to gather support but was ambushed and pursued before being killed near Cilmery, just outside Builth, where there's a monument to mark the place. Llywelyn's body was later buried at Abbeycwmhir, near Rhayader, but Edward I ordered that his head be taken and displayed at the Tower of London. The mural includes the legend of the blacksmith who reversed the shoes on Llywelyn's horse so that its hoof-prints in the snow would confuse his pursuers.

Opposite the mural is the Wyeside Arts Centre (right), opened in 1877, which has served as the town's market hall, court house and cinema. Alongside is Builth's graceful, six-arched river bridge. Our route continues on to the High Street, at one time choked with livestock for the weekly cattle sales as shown (below) c. 1906.

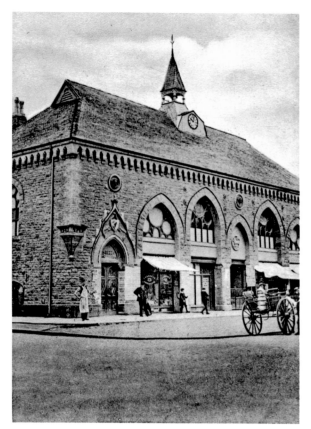

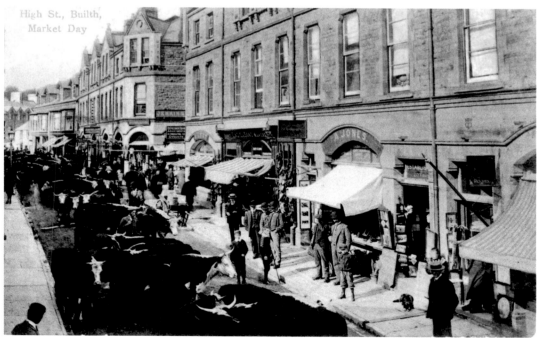

High St., Builth, Market Day

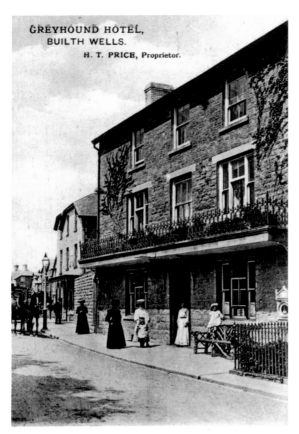

GREYHOUND HOTEL,
BUILTH WELLS.

H. T. PRICE, Proprietor.

To explore the town, we continue along the High Street towards St Mary's Church with its medieval tower. The church is surrounded by four Nonconformist chapels, one at each corner of the churchyard. Further along West Street is the Greyhound Hotel, pictured (left), an excellent hostelry at which to end the day's journey. The Builth Wells Male Voice Choir rehearses here every Monday evening and it's also the meeting-place of the local Heritage Society.

To continue our exploration, we turn back towards the town centre. To the right, along Smithfield Road is the Cattle Market, purpose-built in 1910 to replace the earlier congested street markets. We fork right up Market Street and on the right, in Brecon Road, is the old Builth Brewery of David Williams, now converted into apartments. Continuing along Market Street, on the left is Bank Square, probably the oldest part of town and where the sheep markets were once held, pictured (below) *c.* 1909.

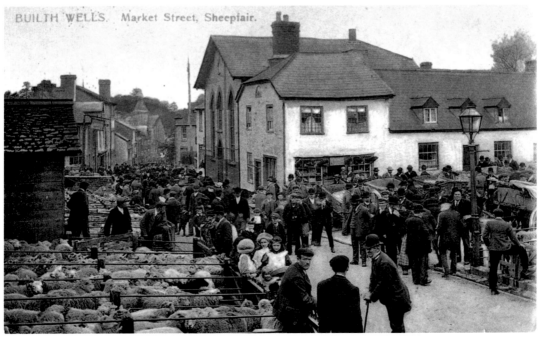

BUILTH WELLS. Market Street, Sheepfair.

Our circular town tour may be completed by continuing along Castle Road and back around past the castle mound towards the main street. On the left is the well-known Lion Hotel, which was built to replace the famous Royal Oak Inn which once stood on the site. The stonemason in charge of building the Lion was David Griffiths and he was so proud of the building's stonework that he stood on his head on the highest chimney to celebrate the completion of the tallest building in Builth!

Builth's history as a market town dates back to the eleventh century and it was granted a Royal Charter by Edward I in 1277. Much of the town was destroyed by fire in 1690, and it has been suggested that stone from the declining castle was used in the town's rebuilding. Builth became well known in Victorian times for its health-giving waters and attracted many visitors to the spas just to the west of the town. The Park Wells and Glanne Wells with their saline and sulphur springs were very popular and resulted in 'Wells' being added to the town's name. The arrival of the Mid Wales Railway, with Builth Wells station just across the bridge at Llanelwedd, helped to attract more visitors. In more recent times, Llanelwedd has become the permanent home of the hugely successful Royal Welsh Show.

A walk down to The Strand leads to the riverside and The Groe recreation area where may be found the Bull Statue (below) which is an appropriate symbol for Builth Wells. The bronze Welsh Black bull was given to the town by Gavin Fifield in 2005.

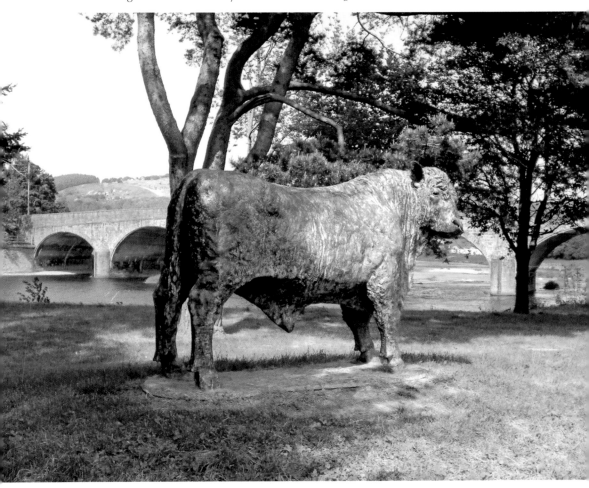

Chapter Three

Builth Wells to Rhayader

16.6 miles (26.7 km)

The Land of the Red Kite

This fairly long section of the Wye Valley Walk may be divided at Newbridge-on-Wye (7 miles) or Llanwrthwl (12.5 miles) if so desired. The path enjoys the company of the river for the first part of the route, before deviating through pleasant countryside then visiting Newbridge-on-Wye. The latter part of the walk includes a climb up to Carngafallt nature reserve before descending into the attractive village of Cwmdeuddwr and the neighbouring market town of Rhayader at the heart of Wales.

We start from The Groe riverside recreation area and follow the Wye, leaving Builth's river bridge behind and passing along a splendid avenue of trees known as 'Abram's Folly'. The trees were planted on the promenade by Abram Davies around a century ago and the picture (below) shows their early growth. He was called foolish at the time but would surely be proud of them now!

The Royal Welsh Showground is on the other side of the river at Llanelwedd, and this has been the agricultural show's permanent home since 1963. The showground has developed extensively since its early days and the event is now one of the most important in the Welsh calendar, regularly attracting around 230,000 visitors during the four days of the show. The showground also hosts numerous other events, including the Winter Fair, and brings many visitors to Builth Wells and its district.

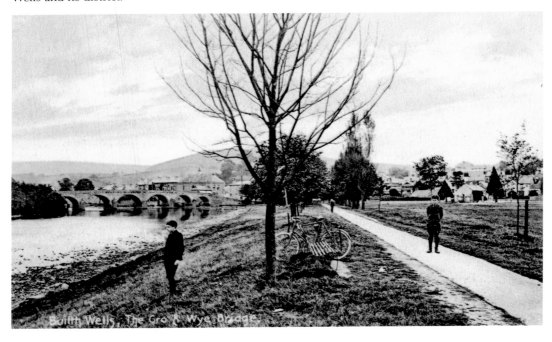

Builth Wells, The Groe & Wye Bridge.

The path turns along the River Irfon at its confluence with the Wye and soon crosses the footbridge, erected in 1984 to replace the earlier 'swinging' bridge of 1839 (below) that once provided a route to the Park Wells spa. After crossing, we turn right to rejoin the Wye and continue alongside its bank, keeping to the riverside to pass under the railway bridge, which carries the Heart of Wales (Central Wales) line from Swansea to Shrewsbury. Away to the right is Builth Road station, once an important junction where the Central Wales and Mid Wales lines crossed – ideal for rail travellers journeying to take the waters.

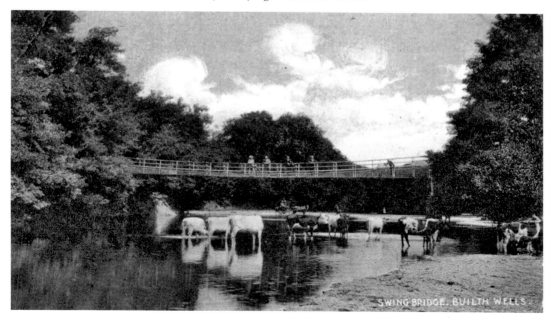

SWING BRIDGE. BUILTH WELLS.

25

After the bridge, the walk continues near the riverbank for about 2.7 miles, then, near a fishing lodge, bears away to a gate, then crosses a stream up to a field. After following fence lines, it passes Porthllwyd farm buildings to reach a minor road, turning left. About 150 yards beyond Brynwern Lodge we turn right through a kissing-gate and, following waymarks through fields, eventually cross a footbridge over the Hirnant brook, continuing to pass through Estyn Wood on boardwalks and reach the B4358 road, where we turn right.

To visit Newbridge-on-Wye, we cross over Wye Bridge and turn right down the main road to reach the village green. The New Inn faces the green and the statue of a drover (left) gives a clue to the village's history. Despite its name, the pub is believed to date from the sixteenth century, having replaced an older tavern on the site. There used to be popular Horse Fairs on the green as shown in the 1905 picture (below).

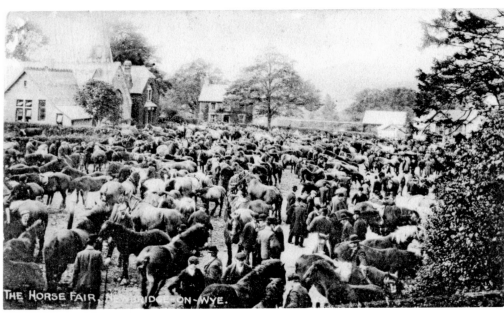

THE HORSE FAIR, NEWBRIDGE-ON-WYE.

Newbridge has long been a traditional river crossing-place and an important stop on the drovers' route between West Wales and the English markets. The procession of large groups of men and livestock including cattle, sheep, pigs and even geese had a huge impact on the places along the route. There were reputedly thirteen pubs in Newbridge, although only the New Inn and Golden Lion now remain. The drovers' trade carried on for centuries and was probably at its height in the 1840s and 1850s. The practice gradually declined with the coming of the steam railway that arrived in Newbridge in 1864. The drovers' tracks across the hills were free, unlike the turnpike roads, where tolls were charged, and giving rise to the Rebecca Riots of the 1840s. The Sun Inn in Newbridge, demolished in the 1970s, was apparently a 'safe house' for the rioters. We'll meet 'Rebecca' later in Rhayader, where there was extensive rioting.

We retrace our steps over the river bridge, turning right to rejoin the Wye Valley Walk and passing the entrance to Llysdinam House. We turn right just before Dol Cottage to follow the waymarkers north through farmland, crossing footbridges and several gates and turning left on the track near Ty'n-y-coed, then right along the end of Ty'n-y-coed Wood. The striking little Dol-y-fan Hill appears to our right, and we continue northward to reach a minor road, following it ahead, then around to cross a stone bridge and pass the turning to Tycwtta. We pass along the edge of Ty'n-y-lon Wood, reaching the common, where the track continues for 1¼ miles. There's a fine view across the valley to Doldowlod House, whose one-time occupant, Mrs Pyne, cut the first turf of the Rhayader section of the Mid Wales Railway in 1859. Appropriately, Mrs Pyne was a descendant of James Watt, who introduced the steam engine.

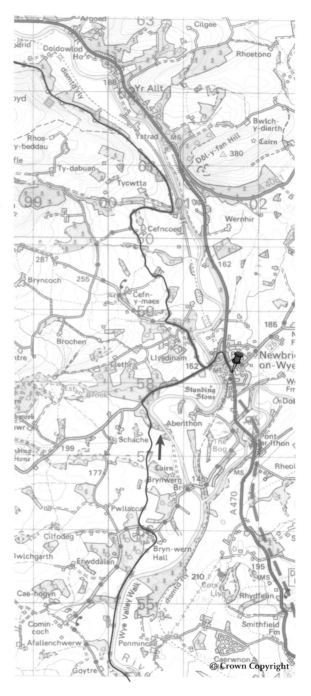

© Crown Copyright

27

The track joins a metalled lane which passes Hodrid House then moves closer to the river, which is noticeably narrower here. Following the lane for 1.5 miles towards Llanwrthwl, we pass an old corn mill and bridge and reach Penuel Chapel. The chapel dates from 1832 and is in a charming setting with its peaceful graveyard and little brook behind (left).

We continue along the lane to Llanwrthwl village and visit St Gwrthwl's Church which is Victorian, but on an ancient site, with a large Neolithic standing stone near the south porch. The church has a lovely altar and stained glass window and a thirteenth-century font. The aptly named Bell Inn once stood opposite the church.

We turn left after the church, then fork right, and about 40 yards past the old school, we turn right through a gate onto a track up to a minor road at Dolgai Farm. We go left for 50 yards, then right up the farm track, progressing up through Cefn Wood to Cefn Farm, passing through the farmyard to the field beyond.

Following the track straight ahead through the gate, we continue across the open hill of Carngafallt, named after King Arthur's legendary hound – Carngafallt is an RSPB nature reserve. We fork right and pass Pen-y-rhiw on our left, and see a delightful view of the town of Rhayader nestling in the valley below. Coming down the slope and losing height fairly quickly, we turn right along the lane by Wernnewydd House then, at the bottom of the lane, take the track on the left to reach the confluence of the Afon Elan and the Wye.

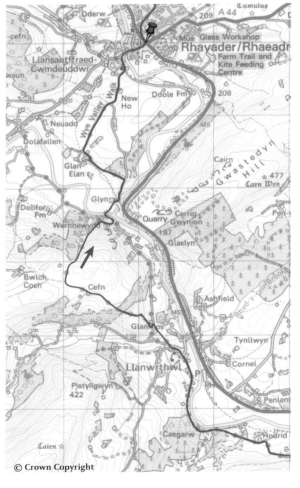

© Crown Copyright

Here is a lovely scene. The Wye north of the confluence is a much smaller river, but going south it has the volume of the two rivers. We proceed to the narrow swaying suspension bridge over the Elan (right) near an old fording point – crossing it is quite an experience!

We turn right to Glyn Farm, and bear right again to continue along the lane before turning left after 400 yards, eventually running parallel to the old railway line. We keep right at the next junction to pass between farm buildings, then right again to follow the lane for a half of a mile mile to reach the tarmac lane which leads to Llansantffraed Cwmdeuddwr (Church of St Bride in the valley of the two waters). The official walk route carries on past the church down to The Gro and riverside, but a pleasant diversion is possible through Cwmdeuddwr churchyard (below). There are plaques inside from Nantgwillt church which was submerged when the Elan Valley dams were built.

Just here is the sixteenth-century Triangle Inn (left), the ideal place for a well-earned drink after our walk. The pub was once called Tafarn-y-Rhyd (tavern on the ford) – the ford was just downstream of Rhayader's famous bridge. The waterfall here gave the town of Rhayader its name: Rhaeadr Gwy (waterfall on the Wye).

The original, more magnificent, waterfall was destroyed in 1780 to make way for the first stone bridge (below). We bear right at the main road to cross over the bridge, which links the two parishes of Cwmdeuddwr and Rhayader and leads us to the centre of town.

(In the opposite direction, the road westward leads to the spectacular beauty of the Elan & Claerwen Valley reservoirs. In the 1890s, a series of huge dams and reservoirs were created to supply Birmingham, which was desperate for a safe water supply. The project transformed the local landscape and took thirteen years to complete. It was officially opened by King Edward VII in 1904).

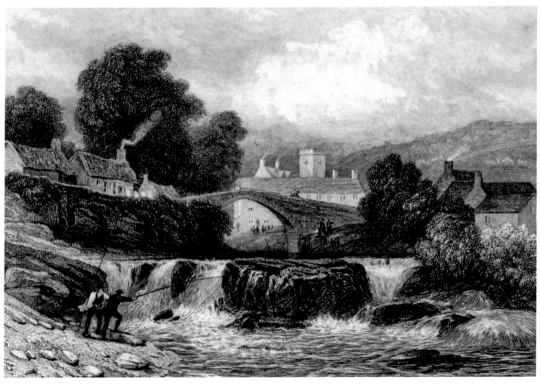

Just upstream of Rhayader Bridge, on the east side of the river is the mound of Rhayader Castle. The castle was built by the Lord Rhys in 1177 to resist the Normans and to defend the first major crossing of the Wye. It was fought over, destroyed and rebuilt after feuding among the local lords and battles with the English Mortimers. It was finally captured by Llywelyn Fawr in 1231, who destroyed the castle and put its garrison to the sword. According to tradition, the bodies lie buried near the porch of St Clement's church. Today only the castle's ditches and mound overlooking the Wye survive, but it's a pleasant spot with picnic tables & benches.

Rhayader is an ancient market town, dating back to the fifth century, with evidence of earlier prehistoric settlements. Located in the heart of Wales, it's the first town on the Wye, some 20 miles from its source in Plynlimon. Situated at a natural crossroads, it has been a stopping place for travellers since Roman times, including monks, drovers and mail coaches. Rhayader's old market hall is pictured (below) c. 1890, viewed from our route along West Street. The market hall was built in 1762 and survived until replaced by the clock tower in the 1920s. Its old gates now adorn the archway of the Lion Royal Hotel, an old coaching inn shown on the left of the photograph. The white-fronted Old Swan Inn is further along on the right and part of this old hostelry survives as a shop, where the timbers still bear the date of 1683. Rhayader continues to hold one of the most important livestock markets in mid-Wales, held at the Smithfield market along North Street.

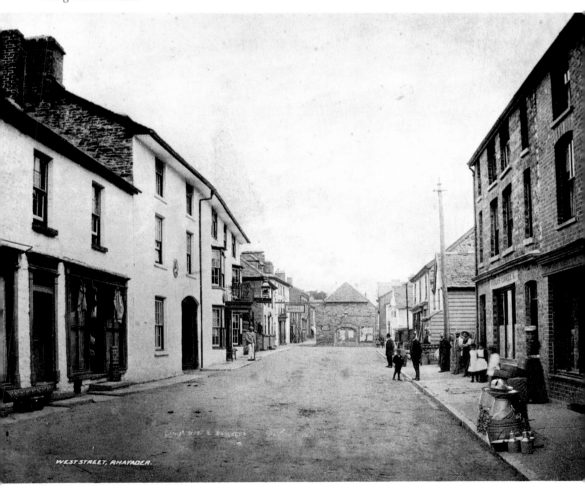

WEST STREET, RHAYADER.

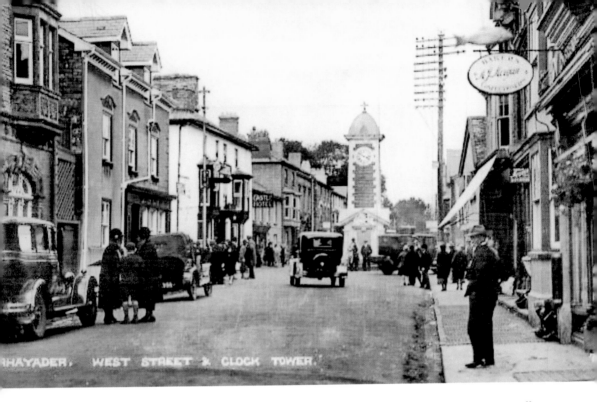

RHAYADER. WEST STREET & CLOCK TOWER.

Rhayader was a staging post on the famous coach road from Aberystwyth to London as well as being on a busy drovers' route. As we follow in their footsteps along West Street, pictured (above) *c.* 1930s, we approach the town clock and war memorial in the middle of Rhayader. The clock tower now marks the historic crossroads midway between North and South Wales and the streets emanating from it are named after the four points of the compass.

Rhayader was a focus for the Rebecca Riots in 1843/4. These were protests by tenant farmers and farm workers against the toll gates across the turnpike roads. Anybody passing through them, taking goods and livestock to market, was forced to pay a fee. The riots were part of a manifestation of general anger and unrest at the perceived injustice meted out to the 'poor and despised peasantry'. They followed on from the Chartist Riots a few years earlier and had similar basic causes. They were called the Rebecca Riots because men would dress up as women and attack and tear down the hated gates in protest against the high tolls imposed, particularly by absentee landlords. The rioters may have taken their name from the Biblical text, Genesis 24:60: 'And they blessed Rebekah, and said unto her ... let thy seed possess the gate of those which hate them'. The rioting in Rhayader was only halted after the introduction of Metropolitan police officers, special constables and a detachment of Fusiliers. The riots were a major social disturbance, but they enjoyed popular public support, making it difficult to convict those who were arrested. They were also ultimately successful – the toll charges have long since been rescinded!

One of the toll-houses still exists in South Street, Rhayader, built in 1799 and the only toll gate not destroyed in the riots. The picture (above) shows the eastern toll gate *c.* 1860. The way east from Rhayader leads to the ruins of the Cistercian abbey of Abbeycwmhir, some 6.5 miles distant. Here may be found the memorial slab marking the final resting place of Llywelyn ap Gruffydd, the last native Prince of Wales.

The Rhayader area is the heartland of the red kite (right). This magnificent bird was once in danger of extinction and its numbers were reduced to around a dozen pairs. Happily, thanks to sustained conservation, the red kites can now be seen again in numbers, with the woodlands of the Wye providing carefully protected nesting sites. At the Red Kite Feeding Centre at Gigrin Farm, just outside town, visitors can watch these majestic birds every day.

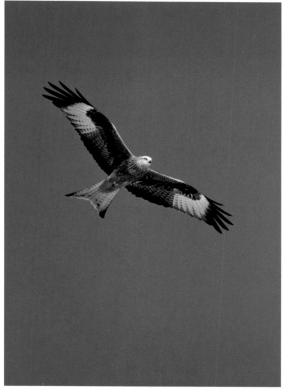

Chapter Four

Rhayader To Llanidloes
16.3 miles (26.2 km) or 15.3 miles (24.6 km)

By two rivers to 'Llani'

This chapter's route continues along the Wye Valley Walk as far as Llangurig then follows a bridleway to the attractive market town of Llanidloes on the River Severn. The route includes some high level walking over open hill country but the highest and steepest section, between Dernol and Llangurig, may be bypassed along an easier low-level route. The day's walk may be ended at Llangurig if so wished, leaving a pleasant 4.5 mile stroll to 'Llani' for the following day. Our journey includes a visit to the delightful Gilfach Nature Reserve, with its restored Welsh longhouse and rich variety of wildlife.

We start from Rhayader's Town Clock and head northwards, appropriately along North Street. The picture (right, top) shows the street facing north, c. 1870s. The stream on the right was known as the Bwgey Brook and anyone who stepped in it was sure to eventually return to Rhayader! One wonders about the past travellers who headed north along this road, which was once guarded by one of the gates hated by 'Rebecca'.

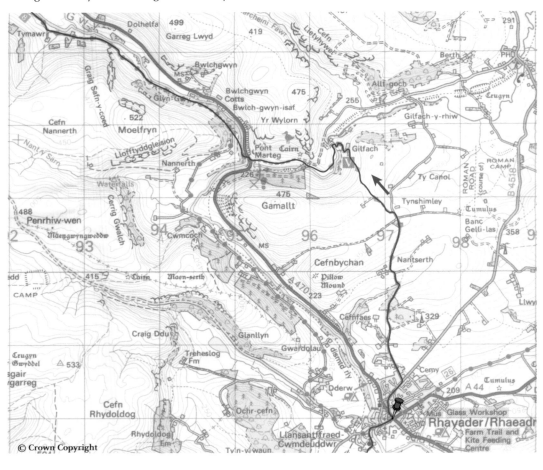

© Crown Copyright

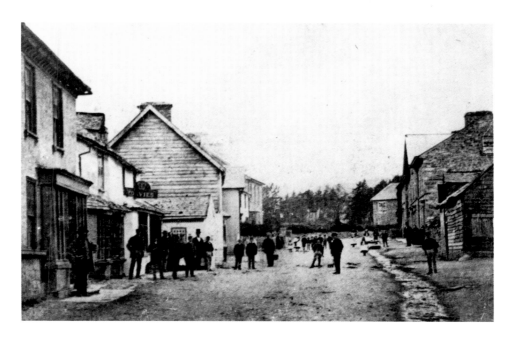

After passing the Crown Inn, which still stands on our left, we reach the leisure centre on the right. We turn right here on the B4518 road signposted to St Harmon then after 500 yards turn left on a minor road (Bryntirion Lane) to carry on uphill, then downhill, then uphill past Upper Nantserth farm to turn left at the waymark post just before Tynshimley. This leads onto a track and we pass through three fields, keeping to the right-hand edge, and through a gate onto the open hillside, climbing to a splendid viewpoint (below) overlooking the valley of the Marteg.

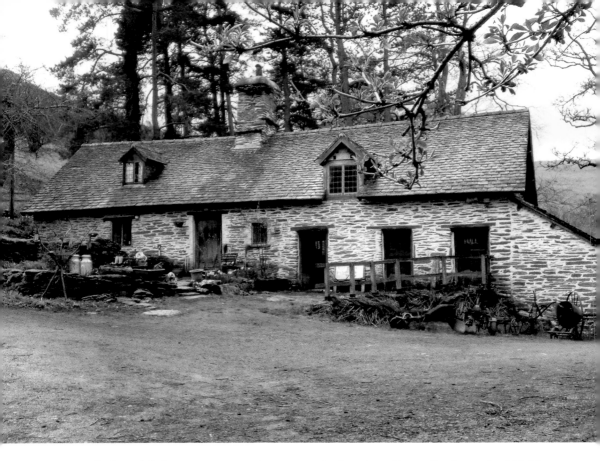

We initially bear left but soon turn right on a path dropping diagonally down the hillside into the Gilfach Nature Reserve, heading for farm buildings near some conifers. Gilfach is a traditional Radnorshire hill farm in an ancient landscape and was acquired by Radnorshire Wildlife Trust in 1988, having been abandoned since the 1960s. The reserve includes a lovingly restored Welsh longhouse that dates from the sixteenth century (above). Welsh longhouses were typically occupied one third by family and two thirds by animals, all living in communion. The main door opened onto a cross-passage, dividing the building into two parts, giving access to the dwelling as well as serving as a feed passage to the byre. Some believed that cows gave more milk if they could see the fire burning in the hearth! At Gilfach, the seventeenth-century chimney approximately marks the divide. Longhouses are normally sited with the human end upslope and the animal quarters at the lower end for better drainage. The farmhouse end at Gilfach is now reoccupied, and there's an information display in the byre. The eighteenth-century barn opposite the longhouse houses an interesting nature discovery centre.

Gilfach has a rich diversity of habitats, from open moorland to broadleaf and conifer woodland, and seventy-three species of bird have been recorded. Its flora and fauna includes rare mosses and lichens, dor beetles and goshawks, sundews, polecats, otters and badgers.

We leave the farmyard left on the lane to cross over the Afon Marteg Bridge, immediately turning left. The walk now follows a Nature Trail along the riverbank of the Afon Marteg for an idyllic half a mile or so before reaching the route of the old Mid Wales Railway and passing a sealed tunnel. This railway traversed some of the most majestic scenery in Britain, and once carried imported cotton to the northern mills as well as intensive coal traffic.

It's difficult to imagine the rumbling of heavy rail traffic in today's tranquil scene. The old railway tunnel is now an important protected habitat for bats hibernating in winter. There are five different species of bat here including the tiny pipistrelle, Britain's smallest bat, less than the length of a human thumb!

We go straight across the old railway line and descend on a path to a kissing gate and then follow a grassy path diagonally uphill to the road. Here we turn left and follow this minor road to the main road at Pont Marteg. We carefully cross the road to a layby and rejoin the River Wye, which is crossed by a footbridge – it's like meeting an old friend again (right)!

We turn right to follow the path diagonally up through woodland then cross several fields to reach a narrow road. We follow this gated lane alongside a very pleasant stretch of the river for nearly 2 miles, passing Safn-y-coed. This is good country for spotting the red kite soaring majestically above, although the occasional low jet aircraft sometimes shatters the peace. The flying machine of the natural kind is much preferred!

At the next two junctions, we turn right, then left, then carry on for about half a mile towards Dernol. The lane to Llangurig swings right near an old chapel, and this is the easier low-level route, particularly recommended if it's planned to walk the whole way to Llanidloes in one day. The Wye Valley Walk goes straight on up the Dernol Valley to climb to its higher, more demanding, route.

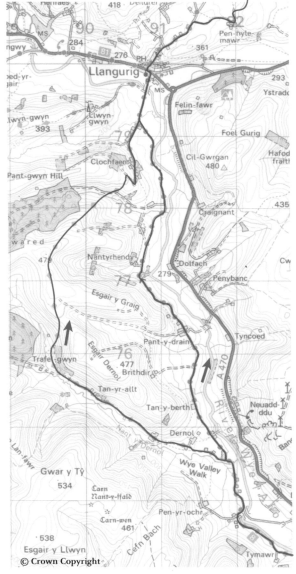

© Crown Copyright

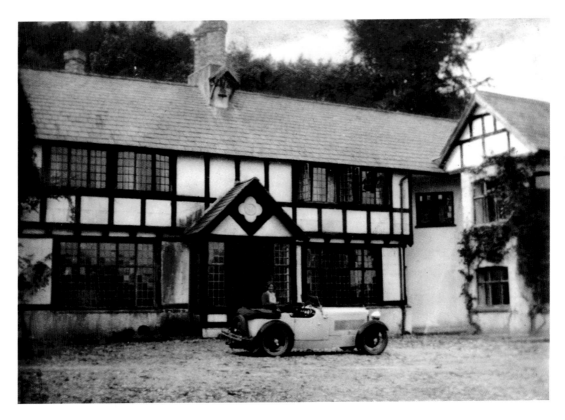

The low-level route follows a quiet, undulating country lane that runs along the west side of the River Wye, enjoying pleasant views across the valley. The lane rejoins the Wye Valley Walk just before Llangurig.

The high-level route follows the Wye Valley Walk up the Dernol Valley along a gated road. Some 600 yards beyond Tan-yr-Allt the path bears right off the road onto a grass track running beneath a wood. It then branches up right and climbs towards a gate leading to an enclosed track going very steeply up the mountainside. After two more gates the gradient eases and the route turns half left, crossing the field diagonally towards a stile. After another stile the path turns right and goes ahead on the ridge line towards a gate which leads onto open land. The small summit ahead is one of the highest points of the Wye Valley Walk at 1,575 feet. The path heads for the right-hand shoulder of the hill and when adjacent to the summit turns half right to go downhill to a gate at a field corner. The path continues past a ruin and descends to the Nant y Clochfaen stream. After crossing the footbridge the path crosses a forestry track and goes diagonally right up the pasture to pass through a gate, continuing to a track where it turns right to zigzag down to a road leading to the Clochfaen. This impressive Arts & Crafts house was rebuilt by W. A. S. Benson in 1914/15 and numerous important people have stayed here, including Prince Albert (later King George VI) in 1917. The house is pictured (above) in 1934 – the car is a Wolseley Hornet. Clochfaen estate presently provides guest and self-catering accommodation and offers fishing and shooting facilities.

The route soon rejoins the lower lane and crosses the river bridge into Llangurig, leaving the Wye Valley Walk for the last time.

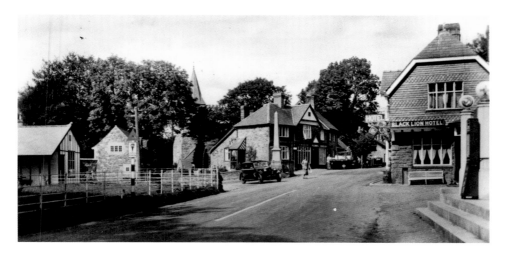

Llangurig, pictured (above) *c*. 1930s is the first village on the River Wye, 10 miles from its source and reputedly located in the 'exact centre of Wales'. The two pubs, the Bluebell and Black Lion both have their origins in the sixteenth century, the Black Lion being partially rebuilt by Arts & Crafts designer, W. A. S. Benson, in 1888. The village drinking fountain is also of Arts & Crafts design, erected in 1898 to celebrate the arrival of drinking water in the village. The fifteenth-century church is dedicated to St Curig.

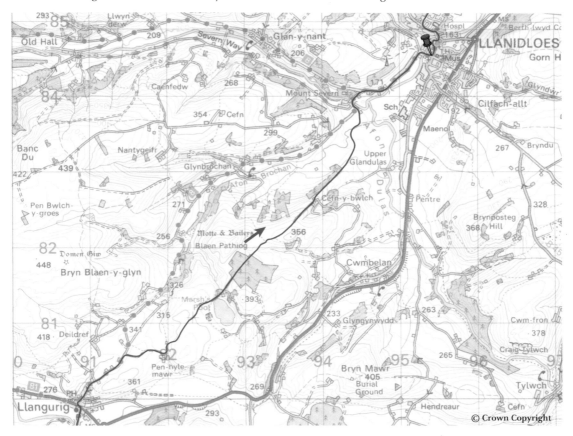

© Crown Copyright

The 4.5 mile walk from Llangurig to Llanidloes takes us from the first village on the Wye to the first town on the Severn. It also links the Wye Valley Walk with our ongoing route of Glyndŵr's Way. We walk up the lane from the Bluebell Inn, and after about 0.6 mile we turn right at a bridleway sign (partly obscured) to follow the tarmac track to Pen-hyle-mawr farm. We go left through the farmyard and through a number of gates marked with bridleway signs taking us on to Marsh's Pool, in a very pleasant setting (below). The lake was created by Thomas Marsh in 1852 (we'll meet him again shortly). We continue following the bridleway signs, to a path through the woods, going straight on and ignoring a right fork. Further on, where the track turns right, we find a concealed path on the left side to again continue straight on (there's no marker post here). At a gate we go straight on, on an uneven path, following bridleway signs to eventually follow a fence line to a gate. We then go straight on up the bank with the hedge on our left to another gate. Keeping straight ahead, we follow the track down a muddy sunken lane to Cefn-y-bwlch where we keep to the left of the farmyard, on the bridleway (avoiding going down the tarmac road). We emerge below Cefn-y-bwlch with a view of Llanidloes ahead. Angling diagonally left now, down to the gate in the field corner, we follow the bridleway signs to reach the lane, turning right and crossing the bridge over the Afon Hafren (River Severn).We then follow the road into the fine market town of Llanidloes, situated at the confluence of the Severn and Clywedog rivers.

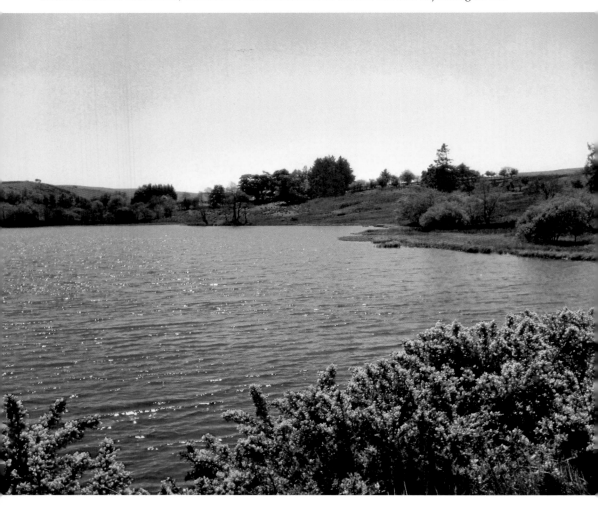

We soon pass the Old Round House which was the first town prison, constructed in response to the town's Chartist Riots of 1839. Thomas Marsh (right) was a prominent landowner and magistrate at the time and was seen by many as having precipitated the riots.

Llanidloes became a leading centre of the Welsh flannel industry from the sixteenth century onwards and its rapid growth led to the development of a number of large woollen mills, which harnessed the water power of the Severn and Clywedog rivers. As we turn right over the Short Bridge we can see the former Bridgend Flannel Mill alongside, built in 1834. Poor working conditions and low wages in the mills contributed to the rise of radicalism in the town, forming common cause with the Chartists' campaign for greater fairness and political reform. The picture (below) shows Llanidloes workers at their looms in the late nineteenth century.

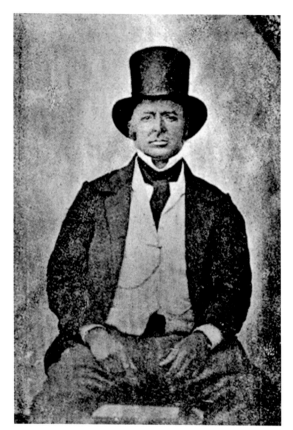

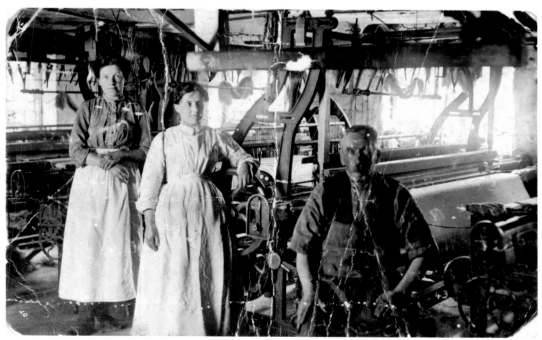

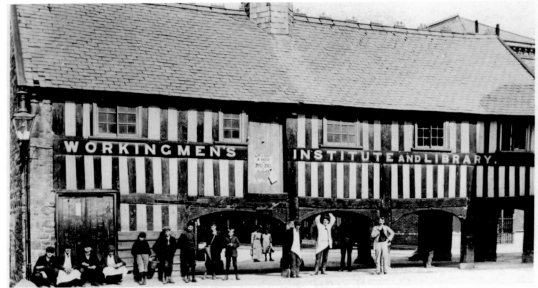

OLD MARKET HALL, LLANIDLOES.

We walk along Short Bridge Street, passing two imposing chapels, to the iconic timber-framed market hall which dates from the early 1600s. The market hall is a Grade 1 listed building, the only example of its kind surviving on its original site in Wales. John Wesley preached here several times and the stone he stood on still remains. The image (above) shows the market hall as the 'Working Mens' Institute and Library' between 1897 and 1908, providing an interesting link with the mining institutes of the South Wales valleys and the far-sightedness that led to their establishment.

China Street is to the right, at the top of which is the timber-framed Mount Inn on the site of the long-gone Norman castle mount. Long Bridge Street is to the left, but for now we head straight on to Great Oak Street where cattle marts and fairs were held – the picture (right, top) dates from the 1880s. The lower buildings on the left were demolished in 1907 to make way for the present town hall.

The Trewythen Arms Hotel opposite was the focus of the Chartist rioting on 30 April 1839. The Authorities were concerned about unrest in the town and three London policemen were brought in and many special constables recruited locally, including almost 300 of Thomas Marsh's tenants. They effectively took over the town and when three local Chartists were arrested and held at the hotel, a crowd confronted the constables to demand their release. Marsh's equivocal behaviour at the scene greatly escalated the situation and the crowd surged forward, violently overwhelming the constables and releasing their comrades. Marsh fled the town and demanded troops be brought in to quell the riot. The Chartists restored the peace themselves before the troops arrived four days later, but the town remained under military occupation for over a year. Many of the Chartists were subsequently arrested and jailed and three were sentenced to transportation, all of whom died in Australia.

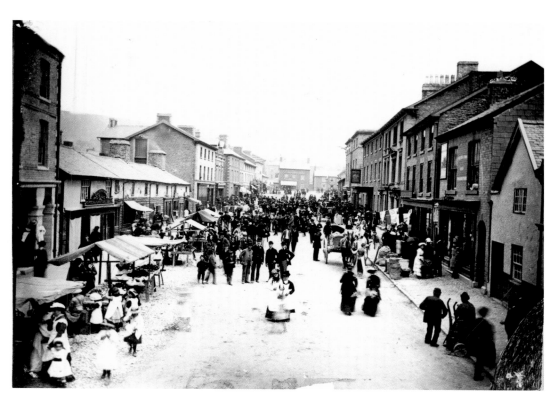

At the end of Great Oak Street, around on High Street, stands the Angel Hotel, one of the locations where the Chartists held their meetings.

The town hall (right), built in Classical style in 1907, was originally a temperance establishment and was a gift of the Davies family of Llandinam who were perhaps concerned about drunkenness in the town (it was David Davies, of this family, who had previously developed Barry Docks). The building provided a sober location for farmers to do their business but they could also visit one of the town's many pubs to celebrate their deals, the pubs outnumbering the chapels by about two to one. The town hall is now the home of Llanidloes Town Council and also houses the town's fascinating museum. The museum displays much of the town's history and one of the more bizarre exhibits is the famous lamb with two heads!

Chapter Five

Llanidloes To Dylife

13.2 miles (21.3 km)

Lost lead mines and the majestic Llyn Clywedog

For the next two chapters we follow an attractive and interesting section of Glyndŵr's Way National Trail, a long-distance footpath which criss-crosses central Wales. (David Perrott's excellent guide describes the complete trail in great detail).

Today's walk passes the beautiful Llyn Clywedog reservoir, then continues towards the wide open spaces of the Cambrian Mountains and the old lead mining village of Dylife. The walk may be divided at the Afon Biga picnic site where there's a parking area.

As we reluctantly leave 'Llani' we can reflect on its proud history, and while remembering its once thriving woollen industry we can look forward to seeing the remains of three important lead mines that also helped to shape the local community. The mines of Van, Bryntail and Dylife employed over 1,000 workers during their heyday in the nineteenth century.

We walk down Long Bridge Street, pictured (below) *c.* 1910, with its numerous shops and pubs including the Red Lion Hotel on the left, another Chartist meeting place. The long-closed Van Vaults, named after the lead mine, is on the right of the picture. We turn left into Church Lane to visit St Idloes's Church with its solid fourteenth-century stone tower (right). Inside we can see the early thirteenth-century arcade of five stone bays brought from Abbeycwmhir Monastery following its dissolution in 1536.

LONG BRIDGE STREET, LLANIDLOES.

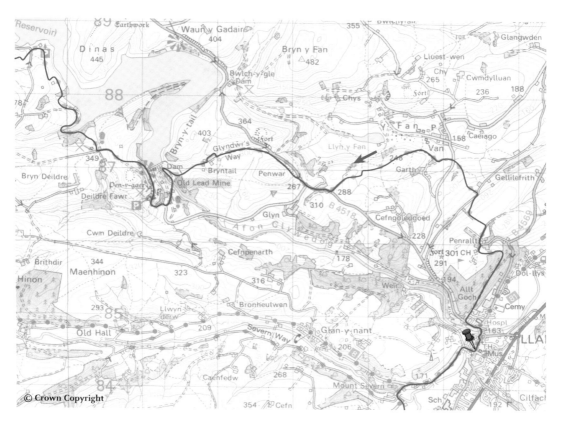

The church also has a fantastic hammer beam roof, with carved angels at the ends of oak beams, dating from 1542. We leave the churchyard at the rear to zigzag down to the River Severn, turning right towards the Long Bridge, and passing the confluence of the Clywedog and Severn rivers to reach the attractive 'Severn Porte' area. There was once a gate in the town stockade here, leading to an earlier timber bridge, upstream of the present stone one. There were also around thirty old houses here, now demolished, creating this pleasant riverside recreation area. We cross over the Long Bridge, which is where the Chartists congregated before marching on the Trewydden Arms. We've now joined Glyndŵr's Way, signposted with the Dragon and National Trail acorn logos, and we'll become acquainted with Owain Glyndŵr, one of Wales's greatest heroes, later in our journey.

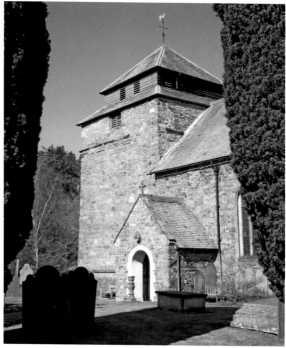

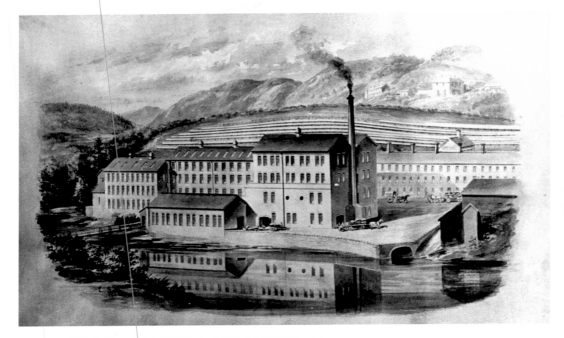

Glyndŵr's Way shares its route
here with the Severn Way and
after crossing the bridge, we
turn left along Westgate Street.
This area was once the location
of several woollen mills with the
Phoenix Mill to our right and
Glanclywedog and Cambrian Mills
on the banks of the Clywedog to
the left. The Glanclywedog Mill
was probably developed from an
earlier corn mill and the *c.* 1860s
engraving (above) depicts the
woollen 'webs' drying and being
bleached by the sun on wooden
frames in the fields above.

Just past the second Tan yr Allt
turning, the trail turns right at a
signpost, soon passing through
a kissing gate and ascending
through woodland. After the
path levels out, we look out for
a sign-posted fork to the left,
leaving the main track to follow a
more minor path up through the
woods, following the waymarks
(left). We turn left at a fence
to fringe the golf course before
turning right on a lane just before
the clubhouse.

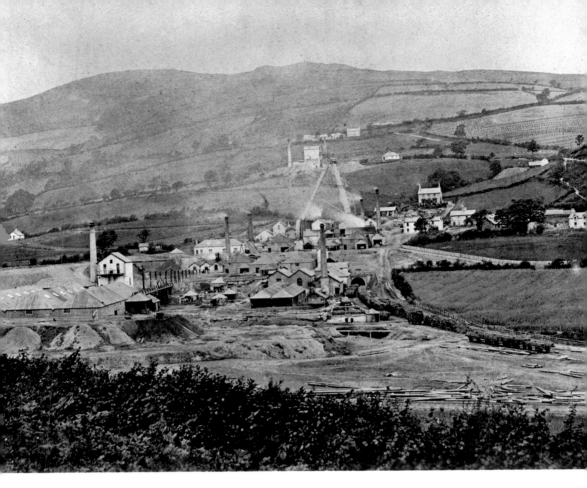

There's a diversion planned here but currently, after about 200 yards, we turn left on a restricted byway through the yard of 'Penrallt' and through a gate. About 250 yards further on we turn left into a field following the Glyndŵr's Way sign (the Severn Way continues straight on). We continue along the hedge line to a stile, with a fine view of the hills and Van village appearing ahead. We veer half-right, descending to reach a road where we turn right. Shortly, we turn left over a stile, continuing with Van ahead, reaching another road and crossing to follow a lane directly opposite. We follow the waymarkers uphill and soon we see the old stack of the Van lead mines to the right.

After a rich seam was discovered in 1865, Van became the world's largest producer of lead ore, employing over 700 men. The village of Van grew up around the mines, with two chapels and a post office, but no pub – the community was clearly very temperance-minded. However, the 'Van Vaults' pub in Llanidloes clearly catered for those who hadn't signed the pledge (and, no doubt, some who had!). Mining activity declined towards the end of the nineteenth century due to cheaper imports and the Van Mines closed completely in 1921. The picture (above) shows a general view of the mines around 1890.

The Van Pool soon appears below and the waymarked route eventually leads up to the B4518 road and turns right. Keeping to the verge, we pass the turning for Clywedog Dam and after another 150 yards, turn left then right through a gate onto a recently diverted route. The diversion takes the trail inside the field hedge, parallel to the road and through another gate, turning left along the track towards Bryntail Farm with great views of the Clywedog valley. The trail diverts around the farm and then passes remains of old lead mine workings.

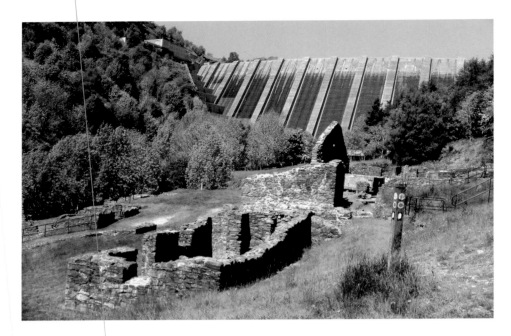

We soon gain our first views of the high Clywedog Dam with the Red Kite Café viewpoint temptingly perched above it on the other side, but there's a circuitous route down and up again to reach it. Dropping downwards we reach the ruins of the processing mills of the Bryntail lead mines, particularly atmospheric when viewed against the background of the towering dam (above). The ore from the mines on the hillside was carried down here by tramway to be crushed to extract the lead. The ancient enterprise was revived in the mid nineteenth century, probably after the best ore had gone.

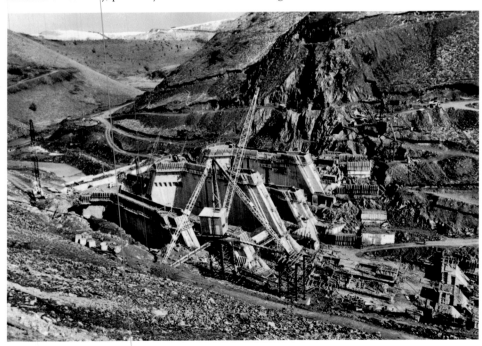

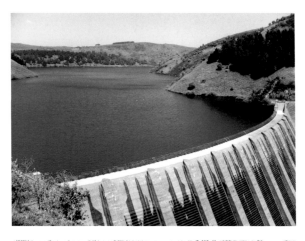

Lead production was never high – the most productive year was 1851 when 384 tons of lead ore were extracted. Production later switched to barytes, the 'white lead' powder used in paint manufacture. After struggling financially for years, the venture collapsed in 1884. The surviving remains date from the mid-nineteenth century and the site is now administered by Cadw. The buildings on the site are helpfully labelled, indicating their function.

Crossing the attractive little footbridge over Afon Clywedog and climbing steeply up the lane and around to the Red Kite Café, we reach the splendid viewpoint overlooking the dam and the Clywedog valley, with the reservoir off to the left – a good place for rest and refreshment. The Clywedog Dam and Reservoir (right) were built in the mid 1960s to regulate the flow of water into the River Severn, preventing flooding in winter and supplying more water in the summer. The lake is more than six miles long, nestling in a steep-sided valley, and is owned and operated by Severn Trent Water. It's contained by the highest mass concrete dam in Britain – the dam is 236 feet high and 750 feet long. The picture (left) shows the dam under construction in 1966, seen from the west bank. At the time, there was strong opposition to the flooding of the valley and in the same year, a bomb was exploded at the construction site, suspected to have been the work of political extremists. The construction work was delayed by nearly two months.

We continue our walk, following the waymarkers, with the lovely Llyn Clywedog in view for the next 3 or 4 miles.

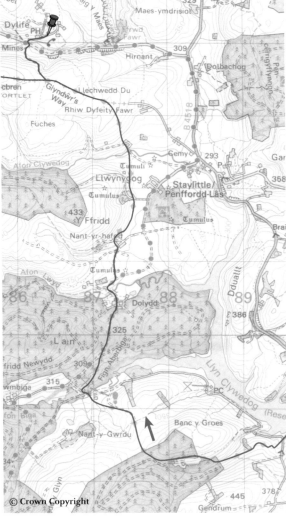

© Crown Copyright

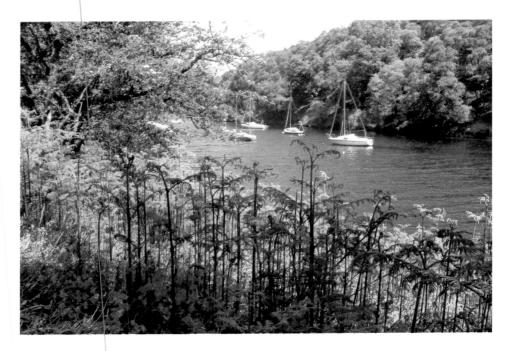

The road alongside the reservoir reaches a hairpin bend, where we turn right through a gate and climb up to reach the road. Turning right we follow the road around a bend then turn right through a little wooden gate alongside a house. The route soon descends to follow the edge of the lake around an attractive little inlet (above), reaching the beautifully-situated jetty and clubhouse of the Clywedog Sailing Club. The club was formed in the late 1960s and soon became popular as shown in the 1969 picture of the Sailing Club beach (below).

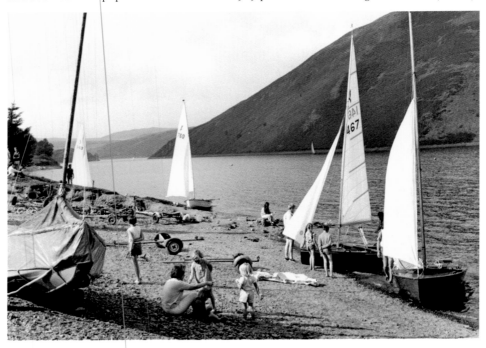

After the Sailing Club we veer right off the road over a stile to continue with Llyn Clywedog to our right, passing the end of a little inlet and the ruins of Foel. Following the signposts we reach a track beside the reservoir where a waymark post directs us left to the road which we cross and continue ahead. The path bends right and left, climbing upwards then contouring around the hill and through a gap in the trees. We eventually descend to a bridge over a stream then walk up to enter the clear felled forestry area. After following the waymarkers through this forestry we leave through a gate to cross rough boggy pasture and descend a track through fields to the Afon Biga picnic site, where there's a parking area. Afon Biga is a fairly remote, but pleasant spot and a good picking-up point if the day's walk is ending here.

We'll carry on for another 3.7 miles, however, to find refuge at the Star Inn in Dylife. Following the waymarked forest track and then the lane through part of Hafren Forest we soon come to the little Afon Llwyd stream at the side of which is a lime doser. A useful signboard explains how the doser lessens the impact of 'acid rain' on wildlife in the streams and rivers.

We continue along the road and at the top of the hill turn left along a track. The route continues along the side of a pleasant green valley passing Nant-yr-Hafod, Llwyn-y-gog and Felin-newydd farms before climbing to open moorland. Approaching Dylife, the Star Inn is down to the right and we look out for a fork right, leaving the track of Glyndŵr's Way about 100 yards before a sheep enclosure. We can see the white-painted Star Inn below near the grey spoil remnants of a long-gone lead-mining industry (below).

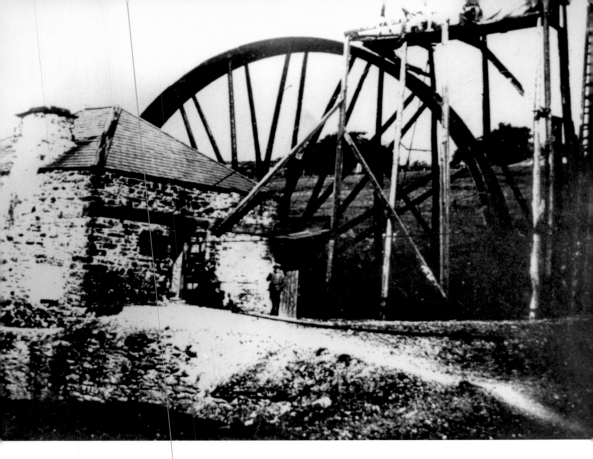

When mining was at its height, Dylife was a substantial community with a post office and school, three chapels, St David's church and vicarage, as well as several pubs, including the Star Inn. Mining in Dylife was probably started by the Romans and may have been revived as early as the seventeenth century. Production was at its height in the mid-nineteenth century and in 1851, the largest waterwheel in mainland Britain was erected here. Known as Martha, the waterwheel was 63 feet in diameter and was used for pumping and drawing. The photograph (above) dates from 1852 and the man standing in front gives a sense of scale. The mine's peak year was 1863, when 2,571 tons of lead ore were raised, second only to the Van Mine. Operations then gradually declined and mining in Dylife had finally ceased by 1901. The village also declined, due to its remoteness, unlike Van which survived because of its closeness to Llanidloes.

The Star Inn is one of the highest pubs in Wales at almost 1,300 feet and is reputed to have originally been a seventeenth-century drovers' inn, although the present pub was probably built around 1860 to provide for the booming mining community. The pub is a fund of stories including the one about the vicar who rode up from Llanbrynmair on his way to the vicarage in Dylife. He'd borrowed a local farmer's horse but the horse refused to pass the Star Inn to continue up to the vicarage. The horse was used to carrying the farmer to the pub, where there were stables and refreshment, and then carrying him home again when drunk!

Chapter Six

Dylife To Machynlleth

15.5 miles (25 km)

On to Glyndŵr's capital

Today we leave Dylife and its lost lead mines, shown (below) *c.* 1852 and continue along Glyndŵr's Way, which we follow through 15.5 miles of superlative country to reach Machynlleth, once Owain Glyndŵr's capital and where he held his parliament in 1404. It's a hard day's walk, with plenty of 'ups and downs' but if car transport is available, it may be divided at Aberhosan (6 miles) or Talbontdrain (9 miles, where there's also a guest house – check with the guest house before parking there).

After going down the lane from the Star Inn to the main road, we turn left, crossing over to turn right up the bridle track, retracing our steps up the bank and perhaps pausing to look back to the Star Inn. We rejoin Glyndŵr's Way at the point where we left it previously to turn right on the trail and pass through a gate and to the left of a sheep enclosure. Following an ancient green track, we soon reach a TV aerial with some low embankments on the left which are in the form of a square. These are the remains of the Roman Fortlet of Penycrocbren (trans. Gallows Hill) and this spot has a macabre story to tell, as on this site was once the gallows of a man who murdered his lover and children.

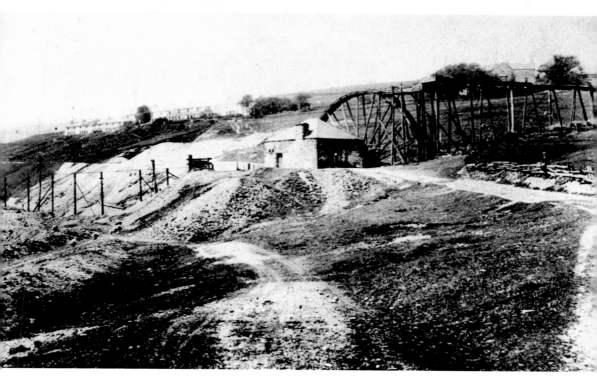

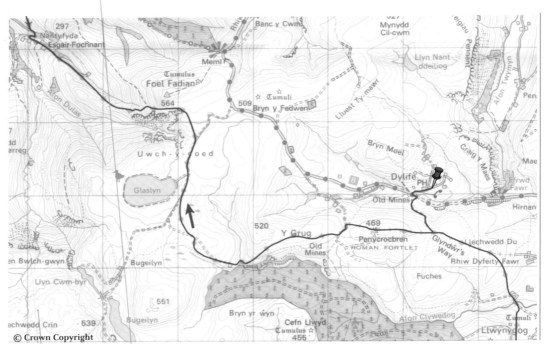

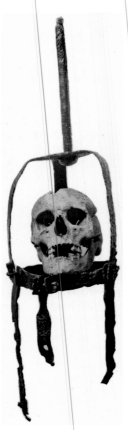

The story relates that in 1719, the mine blacksmith, Siôn y Gof (also known locally as Siôn y Gog) was having an affair with a serving maid from nearby Llwyn-y-gog Farm. When his former lover, Catherine, and their two children appeared on the scene he murdered them by throwing them into a disued mining pit. The bodies were discovered eleven weeks later by some miners and Siôn was arrested and taken to Welshpool, where he was charged with their murders and subsequently sentenced to be gibbeted. He was brought back to Dylife to be executed and, because he was the blacksmith, he was forced to make his own gibbet cage. The cage was hung on the gallows at the top of the hill at Penycrocbren where he was pelted with stones by the crowd and left to die slowly. The gruesome gibbet containing Siôn's skull (left) was uncovered over 200 years later, in 1938, and is now at the National History Museum at St Fagan's.

We hurry from the spot down the track across open moorland, with the western end of the straggling village of Dylife down to our right.

54

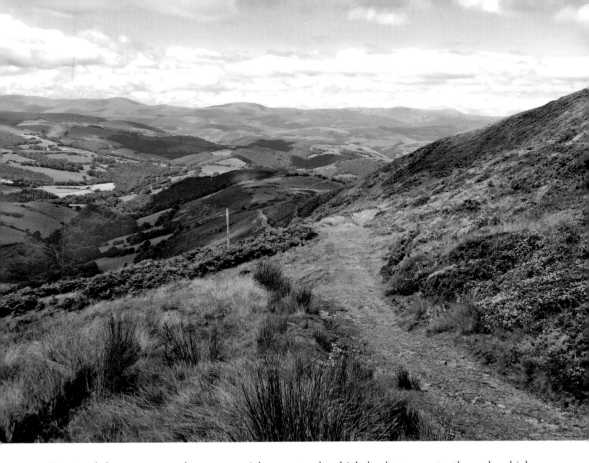

Bearing left at a waymark post we pick up a track which leads to a gate, through which we continue for 100 metres before turning right through another gate, heading for a further gate in the distance. We follow waymarks down into the valley of the infant Afon Clywedog, descending steeply, with care, into the little gorge, crossing a footbridge over a tributary, with some attractive little waterfalls ahead. Climbing up the bank on the other side we pass to the right of some farm buildings, and then follow waymarkers past the remains of the old Cyfarthfa Lead & Copper Mine. The waymarkers guide us to bear right along a green track to reach a fence where we turn right, with the lake of Glaslyn away to the left and the mountain of Foel Fadian ahead. Glaslyn Lake is part of the moorland nature reserve managed by Montgomeryshire Wildlife Trust. The lake's speciality is quillwort, a scarce aquatic plant, which often washes up on the lake shore after bad weather.

Passing the entrance to the lake, we carry on along the track for about 500 metres, looking out for a waymark post where we turn left along a track with Foel Fadian up ahead. The trail continues around the left flank of the hill to reach the highest point on Glyndŵr's Way at around 1,657 feet. The views here are amazing, and there's a wonderful feeling of solitude heading down towards the valley of the Fadian. The slabs are slippery and wet coming down here and we reach a marker post (below) where we turn left to continue down a lesser path, very steep, slippery and rocky, towards the cwm. One can see ahead in the far distance the Cadair Idris range and a wind turbine marking the Centre of Alternative Technology which we visit in the next chapter. We cross the course of a stream and continue down the descending and zigzagging track.

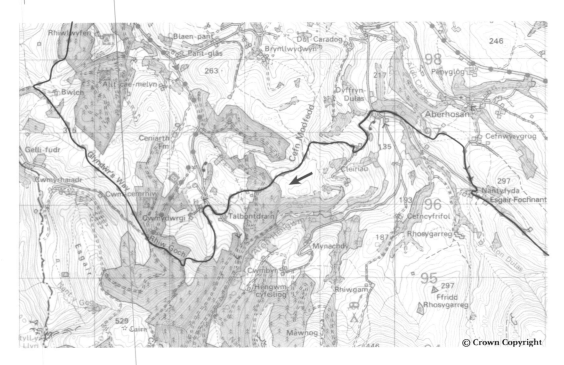
© Crown Copyright

After an exhilarating walk down the pleasant green track along the valley, we reach Nantyfyda where we make a hairpin turn through the farmyard to join a lane, which bends around left before we fork right up a steep lane leading towards Aberhosan. Where this lane swings right, just before Cefnwyrygrug, we turn left through a gate to follow a track (the tiny village of Aberhosan is about 1 km further on).

The track bends left then right before continuing through trees, leading downhill to the road where we turn right. Passing a telephone box, we turn left at the next road junction to cross a bridge over the little stream at Felindulas. We continue ahead up the lane to Cleiriau-isaf where the route passes behind the farm to avoid part of the farmyard. Following the track around, there's a lovely view of the mountains in the distance. After passing through several gates we continue climbing along the main track as it bends around to the left, going ahead through a gateway where the track splits. When the main track swings around right we go straight ahead along a green track with a fence on our left. After passing over a summit we follow the track into forestry. We cross a forest road, continuing downwards, following the waymarkers, past a stone barn before descending to Talbontdrain in a lovely setting.

There's an attractive guest house here where the walk may conveniently be interrupted, leaving a pleasant half-day's walk to Machynlleth for the following day.

Walking from the guesthouse up to the lane, we turn right, following the lane to turn left, as waymarked, at the entrance to Llwyn-gwyn, continuing ahead on the main Glyndŵr's Way path (ignoring an alternative route to the right). Continuing up with the fence on our left, we leave the main track where it swings left to climb steeply up the bank following waymark posts to enter a clear felled forestry area at Rhiw Goch.

After leaving the forestry area, we continue ahead with the fence on the right and a fine view of the valley on our left. The track maintains its height as it traverses the hillside and we pass through several gates, eventually reaching a T-junction at Bryn Coch Bach where we turn right, following the signs, to take the left-hand gate to a green path which drops steeply downhill. As the path starts to rise slightly, look out for a waymark post where we turn sharply left to climb uphill on a track to another post where we swing right over exposed rock and continue climbing steeply up to the hill above, following the waymarks to a forestry gate and stile in the fence corner.

We enter the forestry area, which has been clear felled, to follow the clear track ahead, following the waymark posts and continuing through a gap in a stone wall, after which the track twists and turns, before leaving the plantation through a gate. Our path continues uphill through bracken to pass some interesting-looking rocks on a 'Tump'. There's a great view of Machynlleth down to our right with the Dyfi River beyond and the mountains stretching up to Cadair Idris in the distance. We pass through a gate and then a clear track is followed, gradually descending and bending around to the right through a boggy stretch. We pass through another gate, continuing ahead through the yard of Bryn Glas. The track eventually reaches a road, where we continue ahead and as the road descends and veers left, we continue ahead on a footpath towards Machynlleth (below), carrying on downhill then carefully descending the 'Roman Steps' which are carved from the living slate. Just before the main road, we turn right through gates into the grounds of Y Plas Machynlleth.

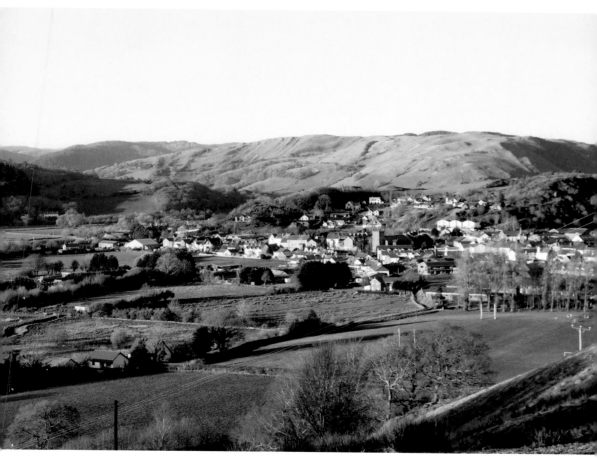

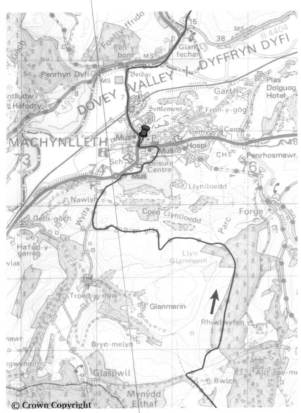

© Crown Copyright

Y Plas (below) dates from the 1700s and the estate was expanded by Sir John Edwards (1770–1850). It was inherited by his daughter, Mary Cornelia, who married the 5th Marquess of Londonderry. She was much loved by the townspeople and after she died in 1906, a memorial bust was erected in the rose garden. The Prince and Princess of Wales were hosted here in 1896 and when King George V and Queen Mary visited in 1911, the whole town was bedecked with bunting and the royal guests were entertained at Y Plas by a choir and harpist. The house and grounds were presented to the people of Machynlleth by the 7th Marquess in 1948 and the grounds became the home of Machynlleth sports clubs and the Bro Dyfi Leisure Centre. Y Plas was restored in 1994 and reopened for a time as the 'Celtica' themed visitor centre. It's now run by the Town Council and has an attractive shop and café displaying portraits of the Londonderry family.

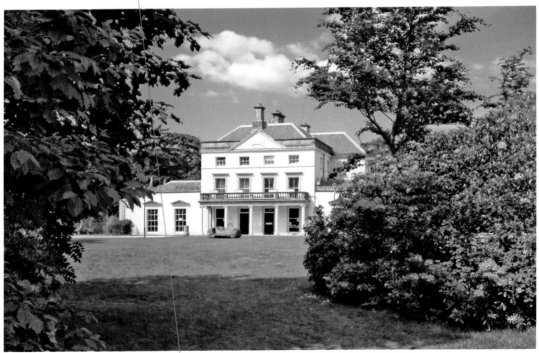

In front of Y Plas is the Owain Glyndŵr memorial stone (right), which was unveiled in 2000 to mark the 600th anniversary of Owain's revolt against the English Crown.

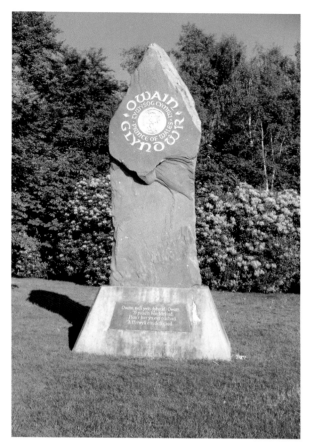

To visit the Owain Glyndŵr National Heritage Centre, we turn right past Bro Dyfi Leisure Centre and follow the trail, exiting through ornamental gates into Maengwyn Street. Across the road is the converted Centre, at the site of the Old Parliament Building (below) where Glyndŵr was crowned Prince of Wales in 1404. The Centre's exhibition features the life and times of Glyndŵr, rebel leader and national hero, and includes a copy of the famous 'Pennal Letter' sent to the King of France in 1406, seeking an alliance, and signed by 'Owain, Prince of Wales' at nearby Pennal. There's also an interesting mural by Murray Urquhart of the Battle of Hyddgen, which took place high on Plynlimon in 1401 and where Glyndŵr achieved his first major victory, defeating the English and Flemings despite being greatly outnumbered.

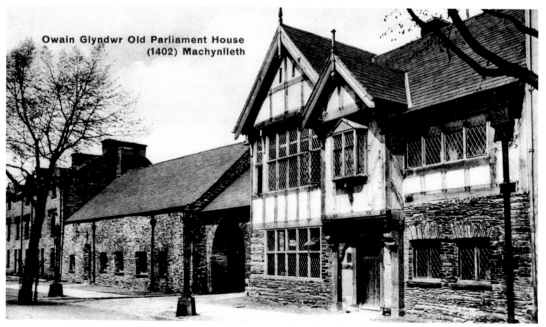

Owain Glyndwr Old Parliament House (1402) Machynlleth

Machynlleth is regarded as the 'ancient capital of Wales' and has much to offer the visitor. Situated close to the centre of Wales at the lowest crossing point of the River Dovey, it was the ideal location for Glyndŵr's Parliament. It has long been a market town, a royal charter having been granted by Edward I in 1291 for a market to be held 'every Wednesday forever'. The Wednesday street market centred on Maengwyn Street remains popular to this day. The old market hall and town hall once stood at the junction, where the town clock is today.

The popular Wynnstay Arms Hotel, pictured (above) in 1911, is on Maengwyn Street and was originally a town house, built in 1780. It was developed as the Unicorn Hotel during the early 1800s and became an important coaching inn on the route from Shrewsbury to Aberystwyth. The name Wynnstay was added during the 1860s with the closure of the hotel of that name in Penrallt Street. The name Herbert was also added, possibly due to a connection with the well known Montgomeryshire family. The Wynnstay has been visited by many famous people, including David Lloyd George. The great traveller George Borrow stayed at the original Wynnstay in early November 1854, recording: 'I arrived at about five o'clock in the afternoon – a cool, bright moon shining upon me. I put up at the principal inn, which was of course called the Wynnstay Arms.' Borrow attended the local Petty Sessions at the old town hall witnessing the case of a farmer accused of spearing a salmon in the river. He described Machynlleth as, 'a thoroughly Welsh town', observing that 'the inhabitants, who amount in number to about four thousand, speak the ancient British language with considerable purity.'

The population is now nearer two thousand but the pure Welsh tongue is still very much in evidence.

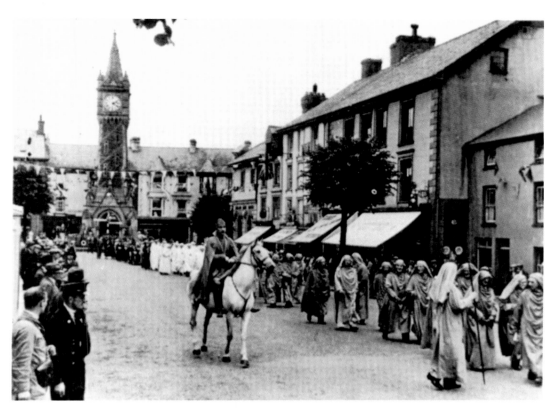

Machynlleth has an attractive eccentricity about it, with an 'alternative, eco' lifestyle feel, probably due to its renewable energy and environmental links. It is also justly proud of its cultural heritage, having a long association with music and the arts. The Urdd Eisteddfod was held in Machynlleth in 1932 when Lloyd George famously attended, viewing the Eisteddfod procession from the balcony of the Wynnstay Hotel. The National Eisteddfod of Wales was hosted in 1937 and the picture (above) shows the Eisteddfod procession in Maengwyn Street.

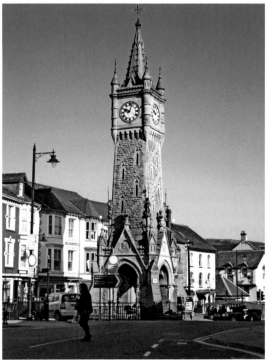

The Town Clock (right) is perhaps the town's main symbol and the hub from which the three main streets radiate. The clock was subscribed for by the townspeople in 1873 to celebrate the coming of age of Viscount Castlereagh, son of the 5th Marquess of Londonderry and Mary Cornelia of Y Plas. The old market hall was demolished to make way for the clock tower, which is considered amongst the finest in Wales.

Chapter Seven

Machynlleth to Tal-y-llyn

15.7 miles (25.3 km)

The magic of Taliesin and Llywelyn's fortress

We leave Machynlleth to cross the Dyfi River into Snowdonia National Park and head northwards on a quiet lane along the Dulas valley, reaching the famous 'Centre for Alternative Technology' (CAT) after about three miles. The CAT opens daily and a visit is highly recommended. We then cross the Afon Dulas to Pantperthog and head westwards on forestry tracks, passing over Foel y Geifr to reach the old slate quarry at Bryn Eglwys. We descend alongside the attractive Nant Gwernol stream to the popular Talyllyn railway station and the village of Abergynolwyn. We continue amid splendid scenery to the atmospheric ruins of Castell y Bere before following in the footsteps of Mary Jones along part of her 'Bible Walk' to end our journey at the beautiful lake of Tal-y-llyn.

Starting from Rhayader's town clock, we walk along Heol Penrallt, shown (below) *c.* 1900. On the left of the picture is the ancient 'Royal House', which probably dates from the sixteenth century. According to tradition, it received its royal title after Charles I stayed there in 1643. We pass the entrance to St Peter's Church on our left then cross to the other side of the road to visit the Tabernacle, which has an excellent auditorium. It hosts many live performances including the popular Machynlleth Festival held in late August.

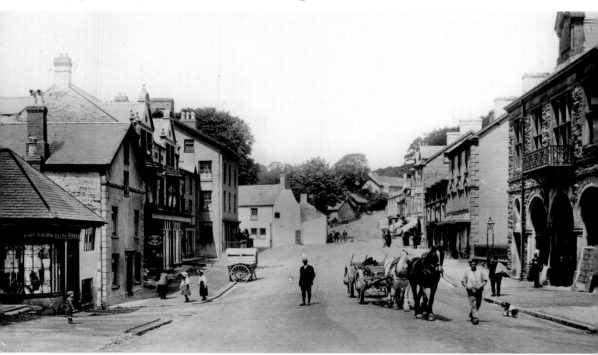

Tabernacle also houses the Museum of Modern Art (MOMA WALES), a series of attractive galleries, which display constantly changing exhibitions of modern Welsh art. A recent addition is the lovely old tannery building at the rear, which is being tastefully restored. A striking permanent exhibit is the *Taliesin Mosaic*, which was funded by the Calouste Gulbenkian Foundation under the directorship of Ben Whittaker. It was created by the Martin Cheek Workshops in 1996 and its three panels illustrate the magical legend of Taliesin. The story relates to Ceridwen's pursuit of the boy Gwion and in the panel (below) Gwion has changed into a bird to escape, but Ceridwen has changed into a hawk to chase him. Gwion eventually changed into a grain of corn to evade capture, but Ceridwen changed into a hen and swallowed the grain. When she reverted to human form she discovered she was pregnant and eventually gave birth to a baby boy who was destined to become Taliesin, one of Wales's most famous and talented bards.

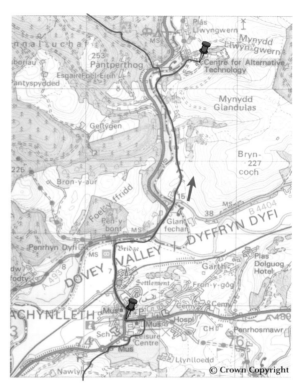

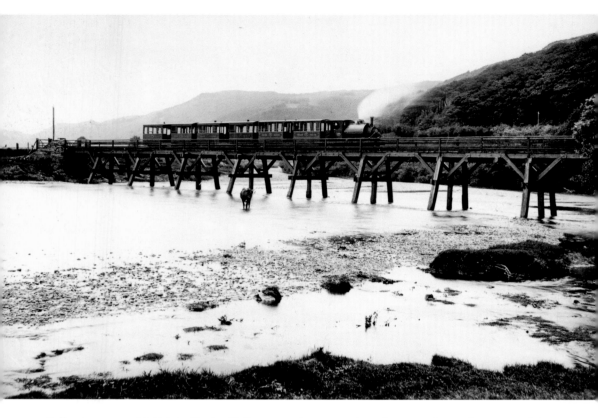

Following around left into Heol y Doll, we continue past the railway station and carry straight on under the railway bridge, crossing the road carefully to the cycleway on the left. We head towards Dyfi River Bridge, again crossing the road just before the bridge, turning right to follow the cycleway alongside the river. After a short distance we reach the Millennium Bridge (Pont Mileniwm), opened in 2001 at a point where the old timber Corris railway bridge used to cross the river, shown (above) c. 1900.

The Corris Railway was the first narrow-gauge railway in Mid Wales and the 2-foot-3-inch gauge line opened in 1859 as the 'Corris, Machynlleth & River Dovey Tramroad'. It was originally worked by horse and gravity, and transported slate from the numerous local quarries down the Dulas valley to Machynlleth and on to the navigable Dyfi Estuary. Steam was introduced in 1878 and passengers were carried between 1883 and 1930, including visitors who were transported on from Corris by carriage to view the scenic delights of Tal-y-llyn Lake. The railway closed in 1948 and was dismantled, but, happily, the track has been restored further up the valley, between Corris and Maespoeth, and is now in steam again, welcoming many new passengers.

After crossing the Millennium Bridge (opposite, top), we follow alongside the main road for a short distance before turning right on the lane signposted Llanwrin. We cross a pleasant little bridge over the Afon Dulas at Pont Felin-y-ffridd, before turning left along the lane towards the CAT, continuing on the cycle route and following the valley of the Dulas. After about 1.5 miles, we reach the CAT with its reception area up to the right.

The CAT was created in 1973 by the entrepreneur and conservationist, Gerard Morgan-Grenville. Located in the old Llwyngwern slate quarry, it's an excellent place to visit and has many interesting and thought-provoking exhibits. Whatever your view of the energy debate – and it certainly has many strands – there's no doubt that renewable energy and conservation have vital parts to play. The CAT showcases numerous innovative ideas and focuses attention on the difficult issues facing the planet. Access to the site is via a water-powered cliff railway (below), which provides a foretaste of things to come. The seven acres of displays reveal the power of wind, water and sun and the importance of recycling. The site also houses the impressive Wales Institute for Sustainable Education (WISE), the UK's most sustainable venue for conferences, meetings and training. The Centre has grown from humble beginnings and, with a dedicated workforce of over 100, has an international reputation as Europe's leading eco-centre.

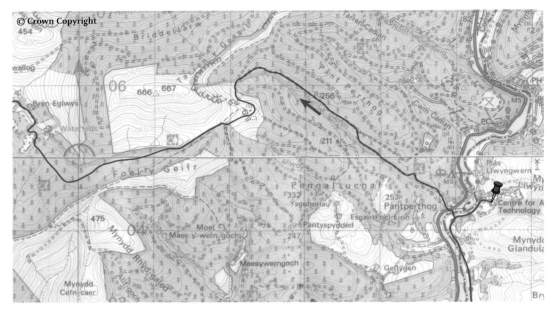

Returning down the lane for about a quarter of a mile from CAT, there's an unmarked footpath on the right, near a gate, which leads to a footbridge over the Afon Dulas and up to Pantperthog. Carefully crossing the main A487 road, we turn left then right on a bridleway just past the school. This soon reaches the forestry road where we continue ahead with the stream to our left. Where the main track bends around right we continue straight ahead, heading in a general north-westerly direction and gradually ascending. After about a mile, we reach a junction where we bear left continuing in the same general direction with the ridge of Tarren y Gesail up ahead. As we reach the head of the valley, our track curves around to the left and where the forestry road swings sharply around to the right we go ahead at a yellow marker post and over a stile. We turn left along the fence line, soon leaving the fence corner post to follow the path ahead up the bank towards some old slate quarry workings. On reaching the disused quarry tips, the path veers left along the side of the hill – care is needed here as the bank is very steep. We continue ahead to pass through another disused quarry, curving right on the path towards a stile near the corner of some forestry. We do not cross the stile, but turn right then left alongside the forestry fence, keeping the fence on the left. Soon, we come to three stiles and we take the centre one, straight ahead, which leads into the edge of the forestry with the fence to the right. The path eventually veers away from the fence line and into the forest, emerging onto a large, open, recently-formed hardcore area with a new forest road leading away from it. We follow this forestry road for about two-thirds of a mile and look out for a footpath leading off down to the right, marked (at the time of writing) with two stones and a large yellow and black arrow sign.

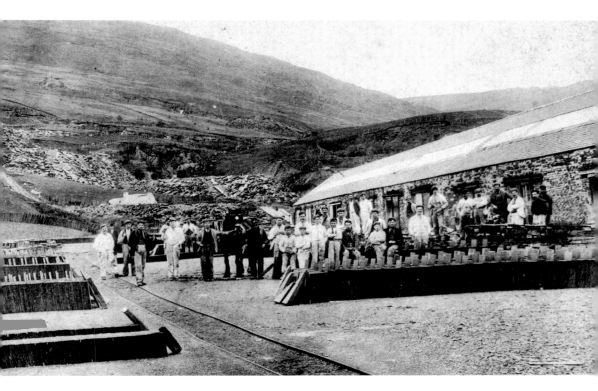

This path downwards is a bit boggy, but we emerge from the trees and another sign points us down the bank to the right, with the old slate workings of Bryn Eglwys below. The route passes around to the right of a large slate tip, curving around to the front of the tip, where we turn right on a green path.

This area was once a hive of activity where the quarried slate was processed in mills and expertly split into roofing slates. The photograph (above) shows the proud workers posing with the stacked slates in the yard outside the mill *c.* 1910. The finished slates were taken by tramway and incline down to the Talyllyn Railway and thence to Tywyn for onward transportation. Bryn Eglwys Quarry operated from the mid-nineteenth century until its final closure after a serious collapse on Boxing Day, 1946. It should be noted that the old workings are potentially dangerous and much of it lies on private land.

Our green path crosses a stile and passes a huge disused quarry on our right. We're now passing a dramatic landscape of slate and we go through a gate to pass to the right of an old slate 'bridge'. The green lane emerges at a junction of roads where we go straight ahead. Shortly, there's a kissing gate on the left with an old sign which says 'Gorsaf – Station'. We go through it and steeply down steps to the fast-flowing Nant Gwernol with its attractive waterfalls. We follow the right-hand bank down, following the footsteps of the quarrymen of Abergynolwyn. The tramway was on the other side of the valley, at a higher level. At a fork we go left down steps and cross a footbridge to admire the waterfall and visit Nant Gwernol Station. Returning over the footbridge, we continue down the right side of the stream towards the village of Abergynolwyn, where the Railway Inn is a welcome refreshment stop.

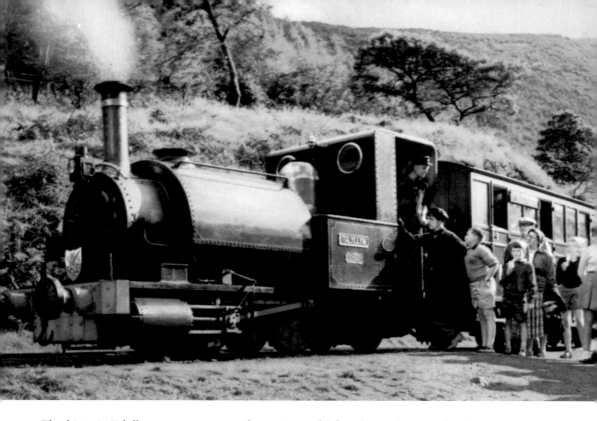

The historic Talyllyn narrow-gauge railway, pictured (above) *c.* 1965, runs for just over seven miles down to Tywyn and is the world's first preserved railway, having celebrated sixty years of preservation in 2011. It was originally built in 1865 to carry slate down the valley to Tywyn, from where it was transported to the port of Aberdyfi for shipment across the world. The gauge is 2 foot 3 inches (the same as the Corris Railway) and it also carried passengers, who now come again in their thousands to enjoy the beautiful scenery along its route. The original locomotives and carriages are still in regular use.

From the Railway Inn, we walk along Heol Llanegryn, passing two old chapels before crossing the bridge over the Afon Dysynni. We carry on steeply up the lane to continue ahead towards Castell y Bere, along the valley for about a mile. Just after Caerberllan, at a junction of lanes, we turn right to head up to Castell y Bere, which we can see on the rocky outcrop up ahead. Just before the rock we can turn left over a stile and scramble up a grassy bank in the centre of the rock to a ladder stile leading to the castle ruins. This is a magical and dramatic place, steeped in history, and a walk around the castle remains is rewarded with some great views of the surrounding mountains.

Castell y Bere is a distinctly Welsh castle, built by Llywelyn Fawr, Prince of Gwynedd, in the 1220s. Llywelyn extended his power over most of Wales and Castell y Bere was the first of a number of stone strongholds he built. Later, his grandson, Llywelyn ap Gruffydd, came to power, and his conflicts with Edward I culminated in Llywelyn's death near Builth in 1282. Castell y Bere was the last stronghold to fall, after which Edward repaired the castle, establishing a settlement alongside.

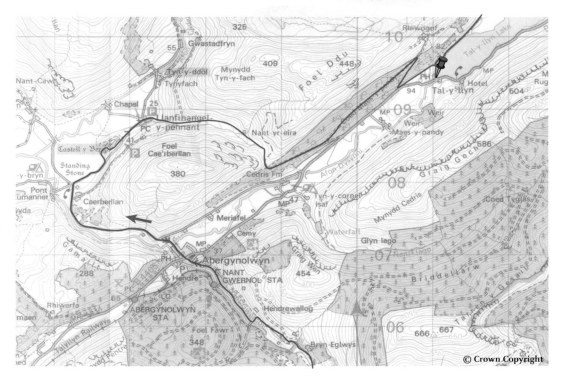
© Crown Copyright

During a further Welsh revolt in 1294, the castle was besieged and probably burnt. The site was abandoned and lay virtually undisturbed for six centuries until it was cleared and explored in the nineteenth century. It's now under the care of Cadw and the view looking south west from the castle ramparts towards Bird Rock (right) is especially breathtaking.

We leave the castle by a path around its flank and continue up the lane to Llanfihangel-y-pennant with its delightful little church. In the vestry there's an impressive relief map of Bro Dysynni and an exhibition telling the story of Mary Jones and her bible. In 1800, fifteen-year-old Mary left her home at nearby Ty'n-y-Ddôl to walk barefoot on an arduous 26-mile journey to Bala to buy a Welsh bible from the Reverend Thomas Charles. She had taken six years to save the 17 shillings for the bible and her journey helped inspire the founding of the world-wide Bible Society.

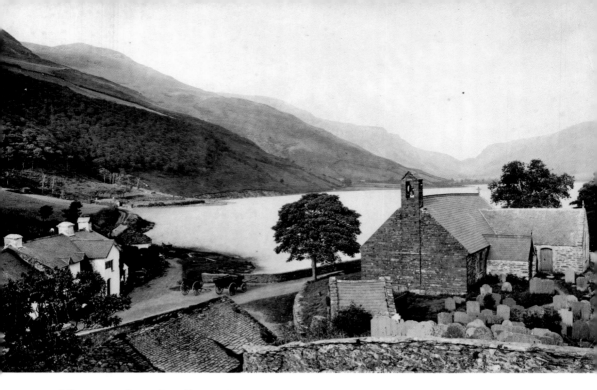

To follow part of Mary's walk, we take the footpath opposite the church to the left of the postbox, passing a house called Llwyn Celyn. We follow the Nant-yr-Eira stream uphill on the marked path, eventually passing two large stones and joining a farm track where we turn right. We cross a ladder stile and aim for the ruined cottage of Nant-yr-Eira in the distance. Passing by the ruin over another ladder stile, we continue on the path for about 300 yards, looking out for a slate wall jutting out on the right, where we turn right to follow the line of the wall. Over another ladder stile, we follow a shale road down through Coed Cedris towards Coed Maes-y-pandy. We drop downhill before forking left on a permissive shale road signed 'Rhiwogof'. After following the main track uphill for about a mile, we reach a cattle grid but, just before it, we turn back sharply right on a little path dropping down through the forest, reaching almost to the road where we switch back left to continue to Tal-y-llyn with its stunning lake, ancient church and two welcoming hotels.

The Pen-y-Bont Hotel is said to be sixteenth-century and inside there's a display relating the story of Jenny Jones who accompanied her first husband, Lewis Griffiths of Tal-y-llyn, to the Battle of Waterloo. Lewis had volunteered for Wellington's army and fought at Waterloo with the 23rd Royal Welch Fusiliers. He was wounded and Jenny spent three days on the battlefield tending his wounds. Lewis recovered, only to be killed in the local slate quarries at the age of thirty-five. Jenny later worked in the laundry of the Pen-y-Bont Hotel. Her grave at Tal-y-llyn churchyard is tended by the hotel proprietors. The hotel and church are shown (above) *c.* 1880.

Just along the lake is the Ty'n y Cornel Hotel, a well-known fishing establishment built in 1844. The hotel has long attracted 'anglers of all shades', with guests plying for the lake's excellent brown trout.

Chapter Eight

Tal-y-llyn to Dolgellau

9.8 miles (15.8 km)

'Tongues of Fire on Idris Flaring'

Today's walk includes a steep and strenuous, almost 3,000 feet, ascent of Cadair Idris by the classic Minffordd Path, then a descent on the northern side of the mountain by the Pony Path to Ty-nant and Llyn Gwernan lake. We then follow paths and lanes to the attractive market town of Dolgellau.

Cadair Idris is a place of extremes and it's recommended that the climb is carried out in good clear summer weather when the walk is safer and the hard work is rewarded by stunning views. It's important to check the weather forecast beforehand as the weather can change rapidly at any time. Conditions in wintertime can be particularly severe, with snow cornices on the cliff edges to beware of. Appropriate mountain clothing and footwear are essential, as well as a map, whistle and compass and adequate rations. It's important to keep to the designated Minffordd and Pony Paths.

From the Pen-y-Bont Hotel, we follow the gated lane along the left side of Tal-y-llyn Lake (below) towards Minffordd. After about 1.5 miles, we reach the B4405 road at a bend and continue carefully along this road for about a quarter of a mile. After passing Doleinion camping-site entrance, there's a high black metal kissing gate on the left through which a little path leads to a footbridge. The track then follows the stream to the gate at the start of the Minffordd Path.

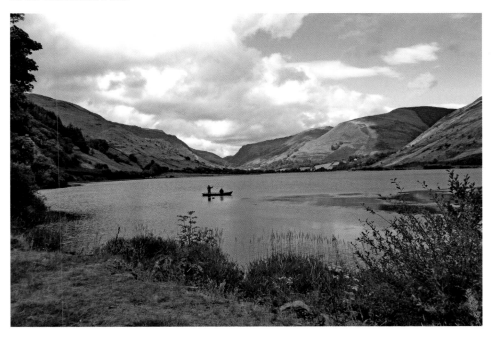

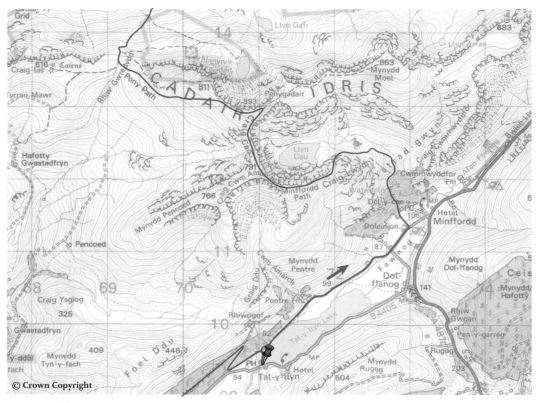

© Crown Copyright

The Minffordd Path takes about three hours of walking to reach the summit then it takes about two hours to descend the mountain on the Pony Path. The path is marked on the aerial view (opposite, top), which is also displayed on the Cadair Idris Nature Reserve signboard sited just inside the gate at the start of the path.

We pass some attractive waterfalls on our right (left) as very steep stone steps lead the way up the mountain, through an ancient oak wood. We eventually cross a small stream, continuing our climb to reach the end of the wood and passing through a gate onto the open mountain. The path continues to wind up steeply and is rocky and loose underfoot as we keep the stream to our right. It then levels a little as we pass some ruins on our left and curve westward into the valley of Cwm Cau.

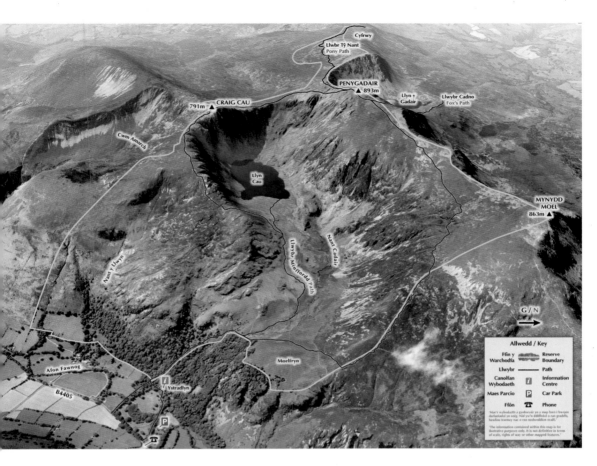

The scene becomes very dramatic as the cliffs of Craig Cau come into view. This appears a wild and desolate place with the dark lake of Llyn Cau ahead and steep cliffs rising around 1,000 feet high above. The valley of Cwm Cau is a classic example of a 'corrie' and the immense crag-enclosed bowl was scraped out by a glacier grinding its way down from an enormous ice-cap. Llyn Cau is one of the deepest natural lakes in Wales – much deeper than the ribbon lake of Tal-y-llyn.

The path is poorly defined over a grassy area and bears left around a boggy area before reaching a large and conspicuous cairn where the path divides. The right hand fork leads on to the lake of Llyn Cau, but we take the left hand fork, climbing upwards on the Minffordd Path. The path winds steeply up and is marked by small cairns. Fine views soon appear on the other side with the tip of Tal-y-llyn Lake becoming just visible in the valley below. The path continues to wind steeply upwards, well-marked by cairns, passing a band of white quartz in the rocks to the right. The route up to the top of Craig Cau is steep and loose and very great care should be taken on this section, keeping well away from the cliff edge, where snow cornices are sometimes formed in winter. The summit of Craig Cau is 791 metres (2,596 feet), but having reached it we have to lose height by dropping down to the col at Bwlch Cau.

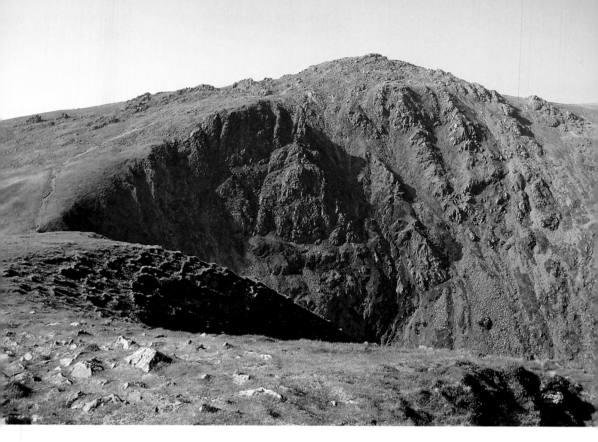

The picture (above) shows the summit of Cadair Idris (Penygadair) from Craig Cau. There are two ways down to Bwlch Cau from the top of Craig Cau – the more dangerous one hugs the edge of the cliff and the other veers to the left away from it and is a much safer route. After descending to Bwlch Cau, we ascend steeply for the last time, keeping to the path through the rocks. A final zigzag brings us to the summit cairn of Penygadair at 893 metres (2,931 feet). There's a trig point here as well as a 'bothy' or shelter and the views are fantastic.

The origin of the name Cadair Idris (Idris's Chair) is uncertain – some say Idris was a Celtic chieftain killed fighting the Saxons around AD 630, some say he was a giant, while others link Idris with Arthurian legend.

Having paused to enjoy our feeling of exhilaration at the summit, we don't want to dally because, according to popular legend, anyone who spends a night on the summit of Cadair Idris will wake up the next morning a poet or a madman!

Returning, we descend between the rocks, this time veering right on the path heading roughly westwards, which is named the Pony Path (also known as the Ty-nant Path). We again need to take great care descending this section, keeping well away from the cliff edge. The views continue to be stunning in every direction, looking down on the lakes below the summit and beyond towards the Mawddach Estuary and Barmouth. This path is named after the ponies that used to carry people and refreshments up Cadair Idris from Dolgellau when it was fashionable for the gentry to undertake walks in the Welsh mountains. Their needs were obviously well catered for!

Cairns marking the route are an important guide and after heading westwards for just over a mile, we reach an intersection of paths and fences at Rhiw Gwredydd where we turn right at a gate to continue down the Pony Path in a northerly direction, veering north east as we zigzag steeply downwards. We follow the path down, using the waymarkers, and passing though a couple of gates and a gap in a stone wall.

This is the route of the Cadair Idris Race from Dolgellau to the summit and back, and near the bottom of the Pony Path, in woodland by a pleasant little stream, there's a memorial stone remembering Will Ramsbotham, a fell runner, who once held the race record. He was tragically killed climbing on Cadair Idris the day after he set his record of 1 hour 25 minutes in 1993. The Race, known in Welsh as Ras y Gader, is held every May and we'll continue to follow its route all the way down into Dolgellau.

Continuing down, we pass through a kissing gate beside Ty-nant farmhouse. We follow the track down to the lane, where we turn right, then after about 100 yards, turn left at a bridleway sign. We pass to the right of the car park and through a gate before forking right at a 'Thomas' camping sign, then immediately right again across the field, heading for two ladder stiles in the corner. There are two sets of marker posts, yellow ones and white ones (which skirt around the boggy ground). We follow the marker posts with fabulous views of Cadair Idris and The Saddle up to the right – there's much satisfaction in knowing that we've been up there!

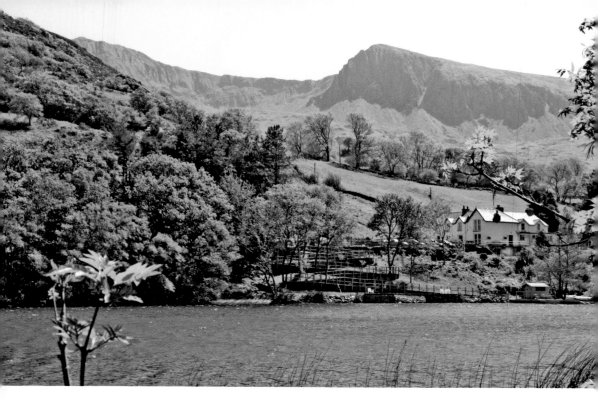

We cross a couple more ladder stiles and go through a gap in a wall, continuing towards Llyn Gwernan Lake. (To visit the Gwernan Hotel, there's a boardwalk going right to a path, which leads up to the lane where a left turn leads to the hotel in about 250 yards). We continue ahead, however, through a gate to reach the left-hand edge of the lake, which is beautiful here with a view across to the hotel and the mountains (above). A variety of fish live in the lake including trout, sea trout, perch and eels and birds here include heron, little grebe, moorhen, dipper and goosander. About two-thirds of the way along the lakeside, the path forks and we veer left, diagonally up the bank and away from the lake to pass through woodland and over another ladder stile, continuing on the track ahead. This leads to Gellilwyd Fawr farm buildings, which we pass to our left to cross over a stile and turn right along the tarmac lane. We pass Gellilwyd Fach to reach the main lane once again, turning left to follow the lane down into Dolgellau and reaching its main square.

'Dolgelly' was described by H. V. Morton in the 1930s as 'a little mountain town with its houses made of the mountains, as though they were made to endure forever'. His description remains relevant today and the buildings tell the town's history in stone and slate. Its crooked streets and irregular spaces are scattered around the central square, which is the town's beating heart. The town's early development was based on the woollen industry, which peaked around 1800, and Meirionnydd cloth was well-known for its quality. Boats carried the 'webs' of cloth down the Mawddach Estuary and they were exported as far as the Americas.

The woollen industry gradually declined in the nineteenth century as the mainly hand-worked looms were unable to compete with highly mechanised mills elsewhere.

In the late eighteenth century, the town became fashionable for people of means wishing to experience the local 'wild romantic scenery'. They were provided with cultural entertainment as well as mule trips up Cadair Idris. Dolgellau remains a popular visitor destination and a walk around the town following the Heritage Society's Town Trail is highly recommended. The town has over 200 buildings listed as being of historic or architectural interest, with the local hard grey dolerite stone and slate much in evidence. Among the buildings of interest are the fine old Meirionnydd County Hall near the river bridge and the old town hall near the square (currently Y Sospan Restaurant). This dates from 1606 and is typically built with large irregular stone blocks. The church of St Mary is, unusually, built of dressed slate blocks.

The town has connections with Owain Glyndŵr, having possibly been a meeting place for his council of chiefs. Later, the Quakers were established here after George Fox, the founder of the Quakers, 'came over Cadair Idris from the south' in 1657 to preach in Dolgellau. Many people in the area became Quakers but unfortunately suffered persecution and many immigrated to Pennsylvania to find freedom to worship in their own language and in their own way. There's an interesting exhibition showing the history of the local Quakers at Ty Meirion, in the square, which also houses the Visitors' Centre.

There were once nine fairs a year held in the square and in the early nineteenth century these apparently could be riotous affairs with the cock-fighting accompanied by mass brawling! The picture (below) shows a much more well-ordered market day *c.* 1880s.

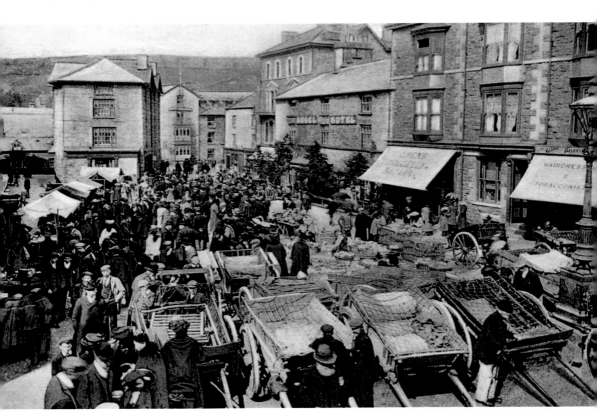

Dolgelly. Ship Hotel.

The town has numerous historic hostelries among its old streets, although some have disappeared. The Royal Ship Hotel (above) still stands proudly facing towards the square. Built around 1800, the Ship has witnessed much of the hustle and bustle of the town and the prefix 'Royal' was added in 1868 to celebrate the visit of the Prince and Princess of Wales to the Principality.

Dolgellau is famous for its music and in recent years has been the home of Sesiwn Fawr (left), a music festival held every July which showcases modern Welsh music and many other genres, with performers from Wales and across the world. The event has attracted huge crowds and is now held on the Marian by the river. The traditional music scene is also showcased at Ty Siamas, a museum and arts centre occupying the old market hall facing the square. The centre was named after Elis Siôn Siamas, a local musician who reputedly played the harp for Queen Anne.

Chapter Nine

Dolgellau To Barmouth

9.7 miles (15.6 km)

'And taste the treats of Penmaenpool'

After the strenuous climb of Cadair Idris, today's walk is relatively easy as we follow the scenic Mawddach Trail along the route of the old railway from Dolgellau to the seaside resort of Barmouth. The trail hugs the south side of the tidal Mawddach Estuary for much of the way, eventually crossing the spectacular Barmouth Bridge. The estuary is peaceful now but once echoed to the sound of ship-building and the roar of steam trains.

We leave Dolgellau, shown (below) from across the valley *c.* 1890, with the summits of Gau Graig, Mynydd Moel and Cadair Idris in the background. From Dolgellau Bridge we follow the Mawddach Trail westward on the south side of the Wnion River. The open space with playing fields on our left is the Marian, now home to Sesiwn Fawr, and after about half a mile, we turn right to cross a footbridge over the Wnion, turning left through a gate to continue on the other side of the river. We then carefully cross the A493 road to continue along the trail at Pont y Wernddu. This is where the Mawddach Trail starts to follow the railway track bed, soon crossing an old iron bridge over the Wnion. A long, straightish section on an embankment follows, with the Penmaenpool reed beds alongside. The reed beds are a Site of Special Scientific Interest and an important breeding ground for otters and wetland birds.

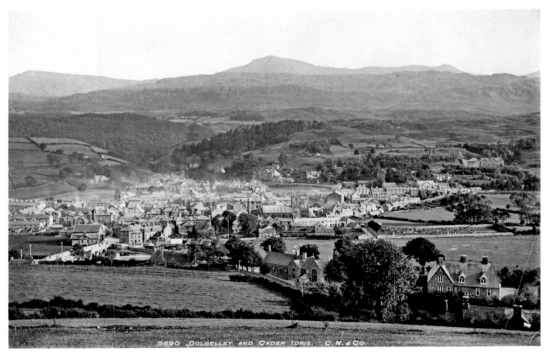

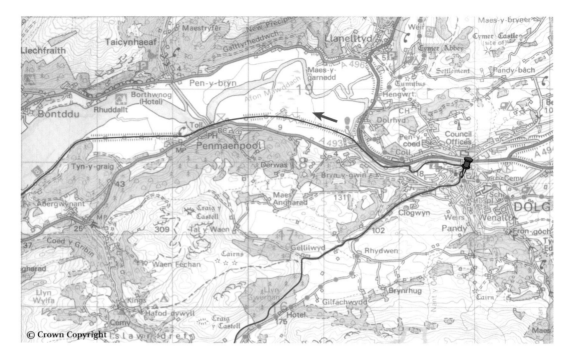

© Crown Copyright

The estuary itself was carved out in the last Ice Age by a huge glacier retreating to the sea and the mountains on both sides provide a spectacular backdrop for our walk, with Cadair Idris to the south and the Rhinog range to the north.

The railway line that once ran along here linked Ruabon with Barmouth and was opened in stages between 1865 and 1868. It was highly popular with Victorian visitors attracted to the fashionable coastal resort of Barmouth and was also used for freight, including slate and copper. The line was worked by steam trains throughout its life and one can imagine the excitement of passengers on the trains over a century ago steaming alongside the estuary towards the seaside. The section of line between Dolgellau and Barmouth was built by the 'Aberystwyth and Welsh Coast Railway' which was later absorbed by the Cambrian Railway, then the Great Western Railway. Sadly, the line was closed to passengers by Dr Beeching in 1965, together with many other local lines.

We soon arrive at Penmaenpool with its charming timber-decked bridge, with a little toll booth on one side of the bridge entrance and the old toll keeper's cottage on the other. The bridge was built around 1879 and a small toll is charged for vehicles but walkers can cross free. There was previously a ferry nearby which had been in operation for centuries. The Penmaenpool railway station was located here and the old signal box still remains alongside the bridge and has been used as an RSPB observation point. The estuary is a haven for wildlife and species of birds present here include oystercatcher, little egret, redshank, red-breasted merganser, goosander, curlew, dunlin and common sandpiper.

Just further on is the George III Hotel with its splendid view of the estuary and bridge (right). The hotel has tastefully incorporated some of the old railway station buildings and the main hotel, dating from around 1650, was originally two separate buildings. One half was the hostelry and the other was a ship's chandler serving the flourishing boat building industry nearby. This is a lovely spot to linger and watch the tide running and these lines of Gerald Manley Hopkins encapsulate the scene:

> Then come who pine for
> peace and pleasure,
> Away from counter,
> court and school,
> Spend here your measure
> of time and treasure,
> And taste the treats of
> Penmaenpool.

The picture (right) shows the steam launch *Jubilee* moored outside the hotel in 1896, having brought passengers up from Barmouth to 'taste the treats'.

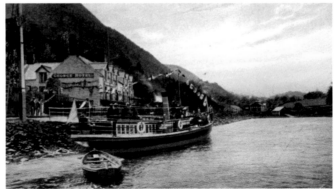

Between 1770 and 1827, over 100 square riggers were launched on the Mawddach, as well as smaller sloops and smacks. Penmaenpool was one of the most important ship-building sites and used oak from the woodlands along the estuary. Despite its small size, many large two-masted schooners were built here and even some brigantines. The ships were towed to Barmouth by rowing boats for fitting the masts and rigging and the launches were attended by large crowds, with celebrations no doubt continuing in the George Hotel afterwards!

The brigantine *Charlotte* was one of the last vessels built in Penmaenpool, in 1862, and is depicted (below) at Barmouth in the splendid painting by Keith Davies, which captures much of the magic of the times. She was named after her owner's wife and travelled the world, particularly on Mediterranean routes. Sadly, she foundered off the Portuguese west coast in 1880 while *en route* to Plymouth with a cargo of copper ore. Her crew was saved by a Portuguese schooner.

In times past, the Mawddach Estuary was a busy sail passage and in the late 1700s boats exported webs of cloth from the area's woollen mills. As this trade declined, livestock and timber was carried and, for a short period, slate from local quarries. Imports included coal from South Wales and limestone from North Wales as well as tea, coffee, wheat, sugar, soap and candles.

It's now time to stretch our legs and enjoy the walk along the trail with great views opening out across the estuary.

We soon see the village of Bontddu on the other side of the water. The hills above it were the centre of a Gold Rush after prospectors found gold in 1834 whilst drilling for copper. The Meirionnydd gold mines enjoyed their boom from 1860 onwards and at their peak over 550 miners were employed. The photograph (right) shows workers at the entrance of the famous Clogau gold mine *c*. 1900. The industry had unfortunately declined by the 1920s but sporadic activity continued – the saying 'there's gold in them there hills' surely remains true today!

Coming around the bend from the Bontddu viewpoint, the estuary is widening and at high tide it's almost like walking by a lake. We pass the pools of Garth Isaf on our left and continue across a bridge over the little inlet to Arthog with the castellated Arthog Hall visible among the trees above the village.

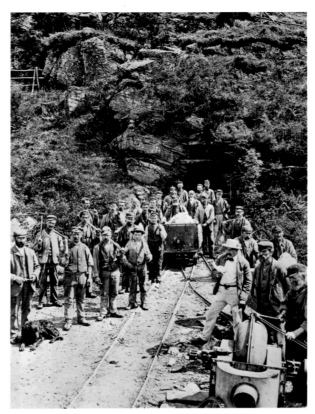

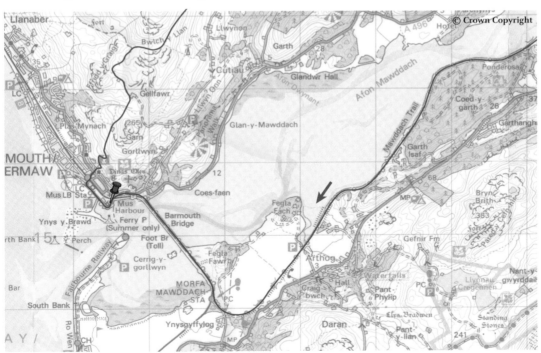

We continue around the bend to arrive at Morfa Mawddach and the impressive Barmouth Bridge which crosses the mouth of the estuary. The bridge was opened in 1867 and carries the Cambrian railway line with a separate footway alongside and is over half a mile in length. Described as 'perhaps the finest artificial promenade in Great Britain', crossing the bridge is an invigorating experience and well-worth the small toll payable at the end. The bridge has a section near the town end that used to open to allow taller ships to pass through on their way up the estuary, but this is no longer used.

From the bridge it's a short walk to Barmouth harbour from where there's a great view of the bridge and Cadair Idris (above). On the way, a pleasant haven may be found at the Last Inn in Church Street. The pub is reputed to be fifteenth-century and in its earlier years was home to the local shoemaker, hence its name. The inn is full of character, with original ships' timbers and inglenook fireplaces. The cliff actually forms part of the pub's rear wall, which is constantly flowing with spring water, forming a well within the pub. A mural depicts the history of the people and the harbour of Barmouth.

Barmouth is rich in maritime history, with its ship-building and trading connections. In the years around 1790, an incredible 250,000 yards of woollen 'webs' were being exported annually. Barmouth vessels also became very active in the slate trade further north as well as carrying timber and many other cargoes. The railway's arrival meant a decline in Barmouth's shipping trade but the 'iron road' brought many affluent Victorian visitors to the resort.

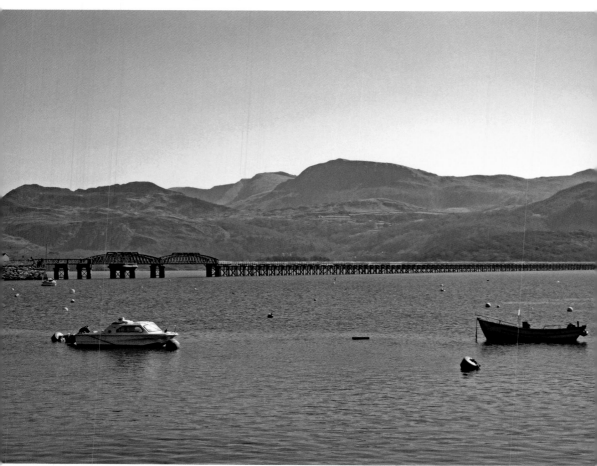

The view (right) shows Old Barmouth from Ynys y Brawd in 1880 and a walk up the steep and narrow paths of the old town is recommended. The climb passes between vernacular stone cottages, built almost on top of each other (below) and is rewarded with great views. A stretch of hillside at Dinas Oleu became the first land owned by the National Trust, given by Fanny Talbot in 1895. Mrs Talbot did many good works for local people, including the donation of a number of cottages to the poor, contributing to John Ruskin's 'St George's Guild' communities. Also up here, in a small walled area, may be discovered the 'Frenchman's Grave'. The Frenchman is Auguste Guyard (1808–1882), an educationalist and philosopher who came to Barmouth after fleeing the Siege of Paris. He became a tenant of Fanny Talbot and they both shared the views of Ruskin concerning social justice, including housing and education for the underprivileged.

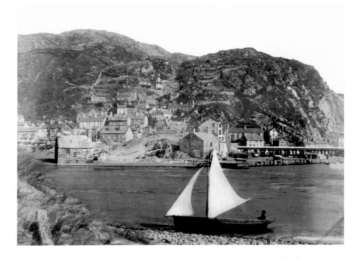

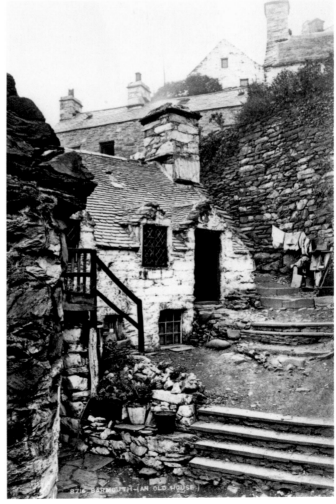

The late Victorian elegance of Barmouth is illustrated in the photograph of High Street in 1899 (left) with the Cors-y-Gedol Hotel on the right. The situation in the town in 1830 was clearly very different, when the Cors-y-Gedol Hotel was the venue for a meeting to discuss 'the matter of notoriety that drunken riots take place very frequently in the town'. The outcome was the building in 1834 of the Round House (Ty Crwn) behind the quay, as a lock-up for drunks and wrongdoers. It was divided into two cells, one for men and the other for women, as there were also women in the town 'who habitually caused disturbances'. Preserved today (left), it has two lifelike figures, one in each half, showing what life was like for the prisoners. The words of the song 'What shall we do with the drunken sailor – lock him in the Round House 'til he's sober' come to mind!

There are some other interesting buildings around the harbour area: Ty Gwyn is a first-floor hall-tower house above the 'Davy Jones' Locker' Café and is one of Barmouth's earliest buildings, probably dating back to the 1460s. Tradition says that Jasper Tudor, Earl of Pembroke and uncle of Henry Tudor, held secret meetings here with supporters of the Lancastrian cause when plotting the downfall of Richard of York. Ty Gwyn was built at the water's edge to provide a safe landing place and was described as 'half in the waves'. Jasper and the fourteen-year-old Henry Tudor had escaped their enemies in 1471, setting sail to exile in Brittany. Henry returned to his native Wales in August 1485 to lead his troops along the coast and through the mountains, gathering support on his way to triumph over Richard III at Bosworth Field – the dream of a Welshman wearing the crown of Britain was realised. Ty Gwyn may well have played its part in these historic events and was restored in the early 1980s. It's now a 'Shipwreck Museum' displaying fascinating artefacts including those from the nationally-important 'Bronze Bell Wreck' discovered off nearby Talybont in 1978.

The splendidly refurbished Sailors Institute on the quay was originally erected in 1890 and houses many artefacts, photographs and paintings. Although modest-looking, it's a little haven and well-worth a visit.

The vibrant scene (below) shows the Barmouth Regatta in 1897. Barmouth's harbour is now the starting point for the Barmouth to Fort William 'Three Peaks Yacht Race' that involves sailing from Wales, via England, to Scotland, and climbing the three highest mountains in each country – Snowdon, Scafell Pike and Ben Nevis – a total of 389 sea miles of sailing, over 11,000 feet of climbing and over 70 miles of running and cycling!

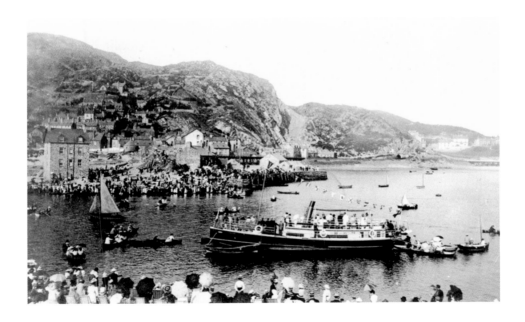

Chapter Ten

Barmouth To Harlech

14.9 miles (24 km)

'To heroic deeds of daring, call you, Harlech men!'

The final leg of our journey begins with an invigorating upland walk along the Southern Section of the Ardudwy Way as far as Talybont. We then join the Lon Ardudwy cycle route northwards to Dyffryn Ardudwy and Llanbedr, following lanes and footpaths and passing through Llanfair to finally arrive at Harlech with its spectacular castle. Our route passes between the coast and the rugged Rhinog Mountains and offers some of the best coastal and mountain views in Wales. We pass through the ancient landscape of the Rhinogydd and visit some fascinating prehistoric burial chambers.

We leave Barmouth, shown attractively (below) in 1865, and start from the railway station, crossing over the town's main street then ascending with St John's Church to our right. We turn left up Gell Fechan Road, continuing uphill and, at the top of a steep rise in the lane, the Ardudwy Way signpost points off to the right along a green track. This is the start point of the Ardudwy Way, a recently-established route, which is well-signposted with a black buzzard on a yellow background. The path soon bends around sharply to the left, and we can admire the views of Barmouth and the bay as we climb. We follow the waymarkers straight on past the atmospheric ruins of Cell-fechan, soon forking right to cross a wall stile and then turn left, heading for Gellfawr.

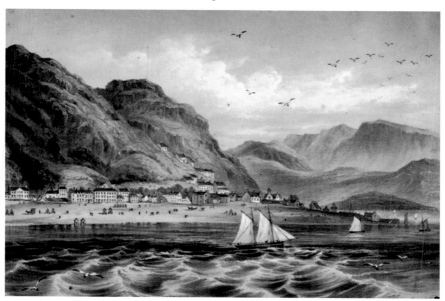

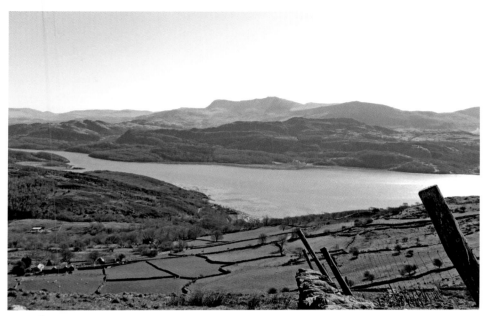

When we reach Gellfawr we turn left following the Ardudwy Way sign, ignoring the footpath passing right in front of the cottage. We soon pass a ruined building on our left and enjoy a fantastic view of the coast and the Lleyn peninsula. On a clear day, the island of Bardsey can be seen at the end of the peninsula and it is said that 20,000 saints are buried there! The path swings around eastward and as we reach Bwlch y Llan, a great view of the Mawddach Estuary and Cadair Idris appears (above). The path veers north easterly and descends to the small stone circle of Cerrig Arthur, where we turn left, following the signs, steeply up to Bwlch y Rhiwgyr (Pass of the Drovers). Having crossed the pass, the way starts to descend, steep and rocky at first, continuing in a north-westerly direction along a wall then a fence, with sea views off to the left.

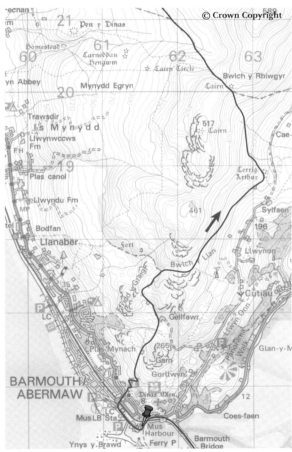

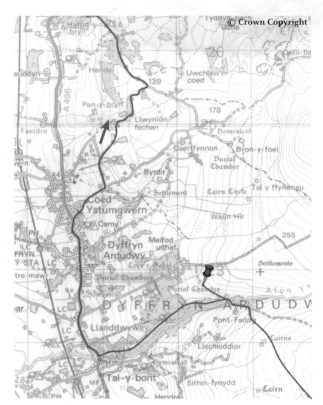

Eventually, we reach a signpost where the southern section of the Ardudwy Way meets the central section (which goes off to the right). We go straight on here, then around left to the charming little bridge of Pont Fadog which crosses the Ysgethin stream. Pont Fadog has an interesting central date stone, with a hole the exact size of a twopence piece. Someone has carefully inserted a coin for posterity! We continue up to a house called Llety Lloegr (English Lodging) where the drovers once gathered before their drives to London. Our ongoing route follows the bridleway opposite Llety Lloegr but first we continue up the lane for about 350 metres to visit a beautiful prehistoric burial chamber (below). Returning to Llety Lloegr we take the path opposite to carefully follow the Afon Ysgethin stream, pleasantly flowing on our left, down into Talybont.

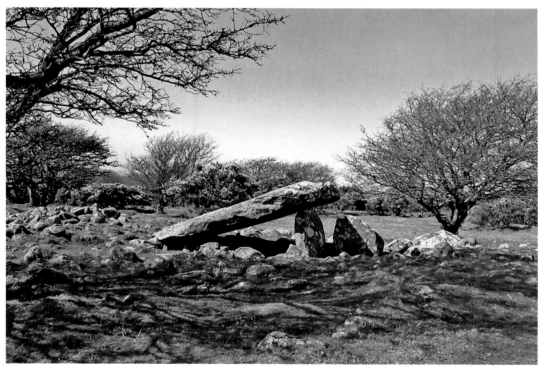

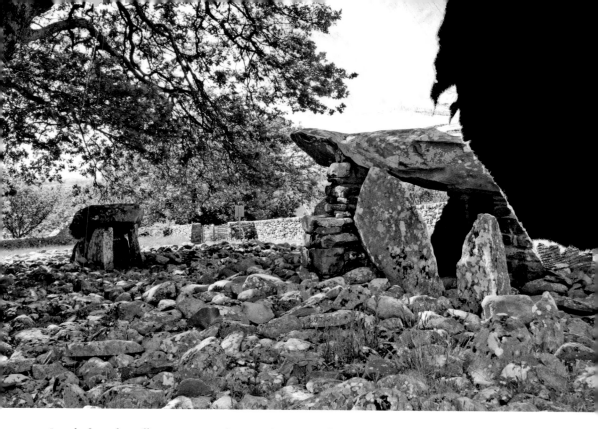

Just before the village, we pass the Ysgethin Inn, which was once a fulling mill and woollen factory. Talybont is on the A496 coast road and we turn right here to follow the footway for about 1.3 miles, sharing our route with the Lon Ardudwy cycleway. As we enter the village of Dyffryn Ardudwy, there's a sign on the right pointing to Dyffryn Burial Chamber. About 150 yards up a little footpath, we discover the fascinating remains of a Neolithic tomb (above) comprising two chambers of different periods, which were originally covered by a stone cairn. The sign on the site informs us that the tomb was constructed between 3000 and 1900 BC, but the site may be even earlier. The tomb was used for communal burial of the dead and is believed to be one of the earliest built in the British Isles. The New Stone Age people who constructed the tomb were among the many communities that inhabited this ancient landscape and the area's many hill forts, cairns, standing stones, burial chambers and stone circles bear witness to the rich prehistory of the Rhinogydd.

After passing through Dyffryn Ardudwy village, we leave the main road near Coed Ystumgwern, turning right to follow the cycle route up the lane at a sign which says Byrdir and Parc yr Onnen (also signposted to Cwm Nantcol). We carry on up the lane for about 0.4 miles before turning left on the cycle route. Continuing on our route along this lane there are great views overlooking Morfa Dyffryn with Tremadog Bay and the Lleyn peninsula in the distance. Forking right, we continue along the gated lane, past Llwyneinion Fechan, and around a couple of 'S' bends. There are some fantastic stone walls here, which seem part of the living landscape, with the Rhinog Mountains stretching above.

a gate at a T-junction, where we turn left, heading towards Llanbedr.
through woodland and drops down into the attractive village of Llanbedr,
place to break our journey. We turn right at the main road (taking care
way) and as we cross over the Artro Bridge, we can look to our left to
d, pictured (below) in 1935. Sadly, the corner shop is now closed but the
king Victoria Inn to our right endures, looking a little different now than in
top). We turn right here to continue on the cycle route – the turning is sign
wm Bychan and Cwm Nantcol. About 200 yards along the lane we find the Ty
Hotel on the left, set in its own grounds. The pub houses an interesting display of
memorabilia associated with the nearby airfield.

We turn left at the Ty Mawr Hotel, following the cycle route along another pleasant
ne. After about three quarters of a mile, we bear left at a junction then after another 150
yards, we look out for a footpath sign at a turning on the right. It's marked 'No Through
Road' and signposted to Ty'n Llidiart Mawr and Garth. We turn right here to pass over a
cattle grid and bear left alongside a wall, up to Ty'n Llidiart. We go through the little gate,
passing in front of the cottage, and then through the metal gate at the other side. Carrying
on along a pleasant green path, there are splendid views of the Artro Estuary to the left.
We soon bear left at a fork in the path, continuing with the fence on the left and passing
through a couple of gates.

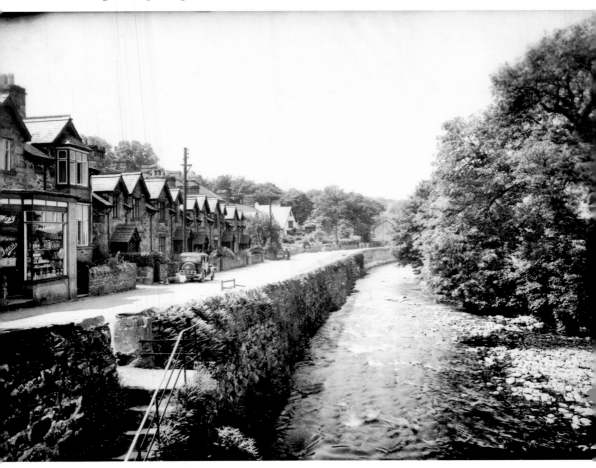

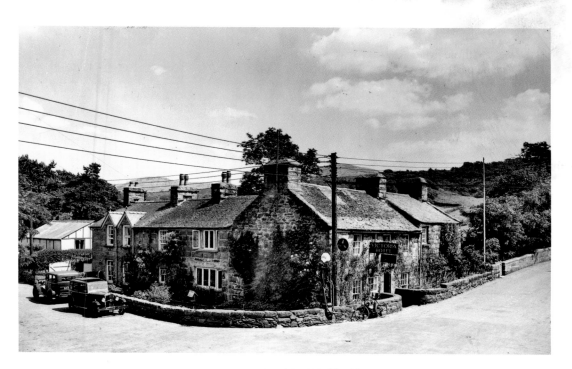

We pass Argoed and aim for a metal gate ahead, continuing on to pass through the yard of a Children's Farm Park. At the bend in the lane, which leads to the Slate Caverns, we continue ahead on a green path. This continues alongside a wall to a metal gate, after which we go along the top of the field and turn left alongside a fine stone wall to another metal gate leading onto the road. We turn right here to enter the village of Llanfair, passing the charming little church of St Mary, and then Bethel Chapel and the Neuadd Goffa – Llanfair's community hall. We've now rejoined the cycle route having avoided a section along the main road. As we ascend, there's a bus shelter on our left with a handily placed seat alongside – an excellent spot to admire the view looking southwards to the bay and the inlet.

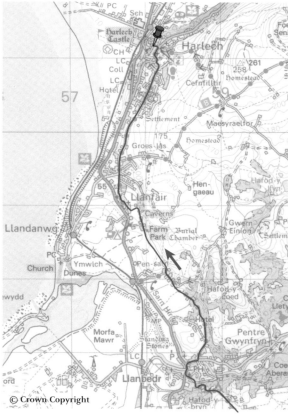

© Crown Copyright

93

We carry straight on along the lane towards Harlech and, to see a view with a very high 'wow' factor, look out for a footpath sign on the left just before Groeslas. The path entry is just past a stone cottage called Penlan and down a little grass track there's a magnificent view of the bay with the mountains of Lleyn and Snowdonia away to the right. Returning to the lane, we continue towards Harlech, with wonderful views continuing and Harlech Castle appearing to complete the picture. We bend around left at Pen y Garth Guest House, down past the library to reach a T-junction. A left turn here takes us on a short detour to another great viewpoint. Just past the garden nursery, on the right, is a rocky knoll overlooking the castle. A display identifies the various mountains in the distance but the 'star' is the magnificent castle standing proudly on its rocky crag above Tremadog Bay and 'standing sentinel, it appears, over the whole of Snowdonia' (below).

Following the wars against Prince Llywelyn ap Gruffydd, King Edward I decided to build his ring of great fortresses in Wales and they remain as a lasting tribute to the fighting qualities of the Welsh. Harlech was started in 1283 and all exterior surfaces were originally rendered and whitened creating an effect even more striking than that we see today. In 1404, Owain Glyndŵr's forces laid siege to the castles of Harlech and Aberystwyth, capturing them both. Glyndŵr occupied Harlech castle until 1409 when it was retaken by the army of Prince Harry of Monmouth, the future King Henry V, 'as much due to a lack of supplies and exhaustion as to the effect of cannonballs'. This was the beginning of the end of Glyndŵr's rebellion and led to his flight and eventual demise.

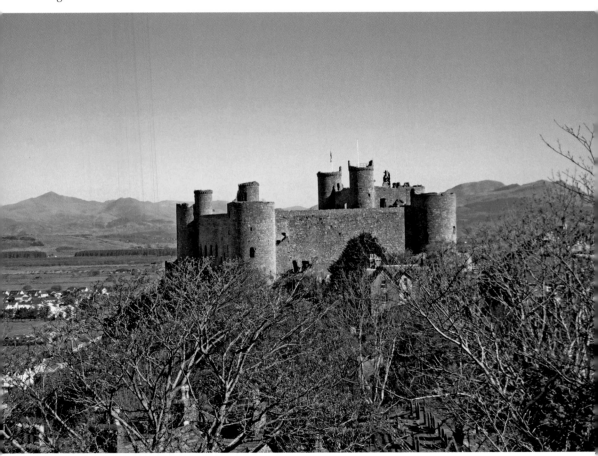

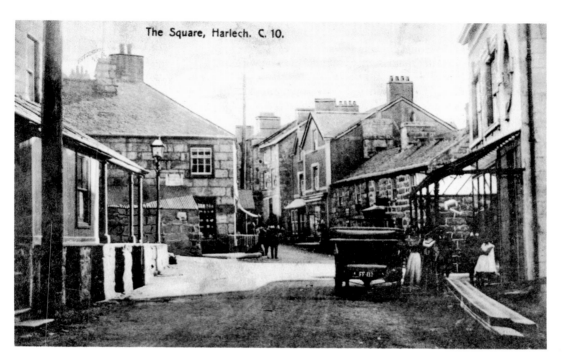

The Square, Harlech. C. 10.

Returning from the viewpoint, we go straight on, around past St Tanwg's church to continue along Stryd Fawr past the Plas tearooms and Blue Lion courtyard, reaching the crossroads at 'The Square' (above) pictured *c.* 1919, looking back. Up to our right is the Lion Hotel, a welcoming locals' pub while a left turn takes us down to the castle. Here there's an interesting bronze statue of a limbless man on a horse (right). This is *The Two Kings*, a sculpture by Ivor Roberts-Jones, which represents Bendigeidfran with the body of his nephew Gwern. In the Mabinogion Celtic legends, Bendigeidfran was king of the ancient Kingdom of Britain and held his court at Harlech rock overlooking the sea. His sister Branwen married the Irish king but their son, the boy king Gwern, was later killed in a war between the two countries. Harlech is associated 'inseparably and forever' with the legend of Branwen, which shows the folly and carnage of war.

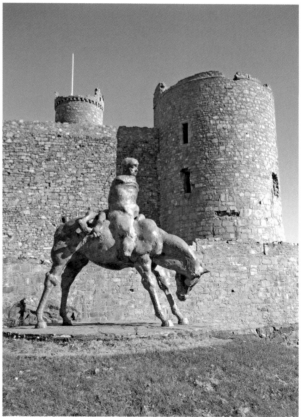

Harlech Castle was again under siege in the Wars of the Roses, when it was the last Lancastrian bastion in Wales. In 1468, a Yorkist force of between 7,000 and 10,000 men attacked the castle, which finally fell after brave resistance. It was the last fortress in the country to be taken and the heroic defence traditionally gave rise to the famous song 'Men of Harlech'. These English words of the song have been rendered in many a rousing choral performance (and also recall our earlier ascent of Cadair Idris):

> Tongues of fire on Idris flaring,
> News of foemen near declaring,
> To heroic deeds of daring,
> Call you, Harlech men!

Seventeen years later, of course, Henry Tudor and his followers were marching through Wales to Bosworth to defeat Richard 'Crookback' and end the Wars of the Roses.

The third and final major siege of Harlech took place in the Civil War, when the castle was again the last stronghold in Wales, this time of the Royalist cause. The castle finally surrendered in March 1647 and was rendered untenable, but fortunately, the order to demolish it was not carried out and the main structure survived to become today's iconic monument. The castle is currently under the care of Cadw and is a World Heritage listed site together with Conwy, Caernarfon and Beaumaris castles. A walk around Harlech Castle's exposed battlements is an experience not to be forgotten.

A visit to Harlech in the 1930s inspired H. V. Morton to write 'I would put the view from Harlech looking towards Snowdon – on a clear day – as one of the finest in the world'. It must be added that the view of the towering castle from the south west (below) is also remarkable – a fitting scene for our journey's end.

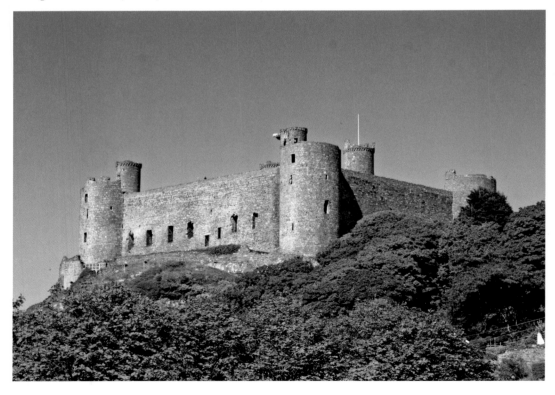